DATE DUE

MR 3 95			
AP 15 '96			
AP 6 04			
NO 3 04			
~~DE 15 08~~			
SE 27 09			

IRENE CHOU

NIE OU

NANCY CHU WOO

YANG YANPING

ZHAO XIUHUAN

ZHOU SICONG

S I X C O N T E M P O R A R Y C H I N E S E W O M E N A R T I S T S

Essay by Lucy Lim

Chinese Culture Foundation
of San Francisco

This publication accompanies an exhibition organized by Lucy Lim, Ph.D., for presentation from December 21, 1991, to March 21, 1992, at the Chinese Culture Center of San Francisco.

Project Director:
Lucy Lim

Project Assistant:
Eileen Seeto

Designer:
Gordon Chun
with Dana Nakagawa

Editor:
Suzanne Chun

Photographers:
Chris Huie, K. K. Leung,
Lucy Lim, and Tsui Wan Miu

Cover Illustration:
Small Painting, by Irene Chou

The Chinese names and terms are romanized
according to the pinyin system.
Printed by EBSCO Media, Birmingham, Alabama

Library of Congress Catalog Number 91-74138
ISBN 0-9609784-1-0

CONTENTS

Funding support for the the exhibition project and the catalog *Six Contemporary Chinese Women Artists* has been provided by the following agencies, foundations, corporations, and individual donors:

National Endowment for the Arts, a Federal agency

California Arts Council

Grants for the Arts of the San Francisco Hotel Tax Fund

Walter and Elise Haas Fund, *San Francisco*

Birmingham Asian Art Society, Inc., *Birmingham, AL*

Bei Shan Tang Foundation Ltd., *Hong Kong*

The Sammy Yukuan Lee Foundation, *Los Angeles*

Lawrence Choy Lowe Memorial Fund, *San Francisco*

The Society for Asian Art, *San Francisco*

EBSCO Media, *Birmingham, AL*

Bank of America, *San Francisco*

ARCO, *Los Angeles*

Sotheby's, *New York*

Butterfield and Butterfield, *San Francisco*

Hanart T Z Gallery, *Hong Kong*

Sponsors:

Grace Wu Bruce, *Hong Kong*
Frederick Gordon, *San Francisco*
Alice King, *Hong Kong*
Dr. and Mrs. K. S. Lo, *Hong Kong*
Kai-yin Lo, *Hong Kong*
Vincent Tai, *San Francisco*
Art and Wilma Wong, *Los Altos Hills, CA*
Dr. and Mrs. Clyde Wu, *Grosse Pointe, MI*
Mr. and Mrs. Gordon Wu, *Hong Kong*
Dr. Michael Yang, *Brisbane, Australia*

Supporters:

Mr. and Mrs. George Bloch, *Hong Kong*
Alice and Calvin Chow, *Hillsborough, CA*
Sarah and Philip Choy, *San Francisco*
Jeannette Shambaugh Elliott, *Tucson, AZ*
Richard and Tatwina Lee, *Berkeley, CA*
Mr. and Mrs. Greg C. K. Liu, *San Francisco*
Jimmy Chieh-ming Lu, *San Jose, CA*
I. M. Pei, *New York*
Dr. Frances Sachs, *Carmel Highlands, CA*
Dr. and Mrs. M. Bruce Sullivan, *Birmingham, AL*
Winnie Wong, *Hong Kong*
Mr. and Mrs. Robert T. Wong, *San Francisco*

Contributors:

June Chen, *Hillsborough, CA*
Joan Lebold Cohen, *New York*
Julienne Lau, *Palo Alto, CA*
Jane Lurie, *San Francisco*
Helen V. Rosen, *New York*
Marjorie W. Seller, *San Francisco*
Mary Tanenbaum, *San Francisco*

The Chinese Culture Foundation of San Francisco sincerely thanks the above donors for their generous support.

SIX CONTEMPORARY CHINESE WOMEN ARTISTS:
Their Artistic Evolution

by Lucy Lim

I have selected the six contemporary Chinese women artists featured in this exhibition because their works, I feel, have made important contributions to contemporary Chinese painting. The paintings I have assembled for this exhibition are representative of their distinctive styles which indicate new developments in contemporary Chinese art. At the same time, the diverse backgrounds and experiences of the artists offer meaningful glimpses into broader social and cultural issues: to what extent are their works shaped by the societies they live in; are there special constraints on their artistic careers; and do certain features in their works identify them as being the products of women artists? Due to the limited scope of this project, there are of course many other important women artists I have omitted, because of limited time, insufficient resources, and various obstacles. Of the six artists featured, four are from the People's Republic of China—Nie Ou, Yang Yanping, Zhao Xiuhuan, and Zhou Sicong. (Yang Yanping and Zhao Xiuhuan currently reside in the United States.) Two artists, Irene Chou and Nancy Chu Woo, were born in China but have spent most of their lives in Hong Kong, where they now live. All six artists studied traditional Chinese ink-and-brush methods (*guohua*), either through formal education, independently, or under private teachers. How they have responded to their environment and the changing times is reflected in their art: visions of reality that are subjective, conceptualized, idealized, symbolic, transitory, or spiritual. In spite of different styles and subject matters, their paintings share a common feature: a re-creation of reality through distillation, abstraction, or manipulation. For the artists from the People's Republic, this has not been a natural evolution of style but a deliberate assertion of will and independence. Their search for artistic identity may be understood in light of China's revolutionary changes under the new socialist government, an understanding of which will perhaps lead to a better understanding of their roles as artists in the new China and in the international art world.

THE SOCIALIST REGIME OF THE PEOPLE'S REPUBLIC OF CHINA, which came to power in 1949, radically changed the country's centuries-old artistic tradition as well as its political and social systems. Under the new political dictates, art should serve the masses—especially the workers, peasants, and soldiers—specifically to educate and politically rehabilitate them. Abstraction and individualistic expression, inherent features of many traditional Chinese paintings, were criticized by the new government as elitist and esoteric and therefore incomprehensible to the masses. These criticisms were essentially aimed at literati painting (*wenrenhua*), one of China's most cherished and influential schools of painting. (As is now well known, China's other venerated cultural traditions were also attacked, the Peking Opera among them, and such attacks intensified during the Cultural Revolution from 1966 to 1976.)[1]

The literati theory of painting, formulated in the eleventh century by a coterie of scholar-painters, advocated individualistic and expressive qualities in painting.[2] Paintings should not simply record observed phenomena accurately, but should, instead, express the artist's inner personality and capture the spirit or essence of the things depicted. In effect, literati painting was a reaction against the descriptive realism of the contemporary Song Academy painters, who produced detailed, representational, and often colored renderings of nature and everyday scenes. In an effort to convey the inner spirit or essence of reality, while expressing their own feelings and personalities, literati artists—in a sense—abstracted from nature and distilled observed reality in their paintings. In the creative process of abstraction, literati artists imposed their intellects, emotions, and artistic sensibilities on the images depicted and re-created reality. Partly because of its deliberate departure from descriptive realism, literati painting often appeared abstract, characterized by abbreviated forms and the sketchy use of brushwork. Yet elements from the natural world were always recognizable, no matter how abstract the painting became, for example, in *Chan* (Zen) Buddhist paintings, which were associated with the literati school. (Abstraction in traditional Chinese painting generally means a simplification of forms—sometimes even distortion—and a reduction of realistic elements.) The ideals embodied in literati aesthetics—the quest for personal freedom and spiritual reality—have had tremendous influence on Chinese painters throughout the centuries. The visions and aspirations of artists from various periods of Chinese history may be glimpsed in their paintings, which often reinterpreted the literati ideals in very personal terms, using nature as a metaphorical projection of their inner emotions. During the fourteenth century, for instance, when China was ruled by the Mongols, literati painting flourished as a pictorial form of resistance to the foreign invaders and was frequently veiled with hidden meanings and symbolic allusions.

Literati painting tended to appeal to the educated and, in particular, to the scholar-gentlemen, a special class in traditional Chinese society able to understand and appreciate the subtleties of the brushwork, the intellectual and philosophical connotations, the highly personal and sometimes oblique meanings, and the depth of feeling the paintings imparted. It was therefore inevitable that the cultural officials of the new socialist regime of the People's Republic could not condone such an esoteric, high-minded, and individualistic form of art in the new classless society they were trying to establish. How could the simple, uneducated peasants and workers be expected to understand this elitist art? Individualism had no place in China's new society; conformity became the norm and those who deviated were criticized and punished. Individual will and freedom indeed had to be suppressed, and all artists came under the government's control. So the new political and social changes brought new artistic directives and the government revised the art school curriculum accordingly. Western realism, which had increasingly influenced traditional Chinese painting in the late nineteenth and early twentieth century through China's contact with the West, began to dominate the new art of China. Socialist realism was adopted as the official art form.

The new generation of artists trained under the system of the People's Republic learned Western methods in their early training: life drawing, sketching, and the use of color, mainly watercolor and gouache.[3] The emphasis was on the human figure and portraiture, usually drawn with pencil or charcoal. (Life models in the classroom

were clothed after 1957 when a wave of anti-rightist sentiment intensified and nude models were banned.) Art students also drew still-lifes and visited the countryside to sketch the peasants and village scenes. Drawing directly from life and nature taught the young artists to see things as they were and to gradually master the techniques of Western realism, instead of copying the works of China's ancient masters as previous generations of artists had done. Their teachers were trained in Western methods, some having studied abroad in Japan or Europe. Some teachers were even sent to the Soviet Union specifically to learn socialist realism. In addition, the curriculum for these young art students in the preparatory schools—such as Beijing's Youth Palace (Municipal Children's Center), attended by Nie Ou, and the Central Art Academy Middle School, attended by Zhou Sicong and Zhao Xiuhuan—included a category called "creativity" (chuangzao), whose main subjects were book illustration and poster art. Using their imaginations and relying on their training in life-drawing and sketching, the students created illustrations for storybooks and posters whose purpose was usually propagandistic.

Art became a useful tool for spreading the new political ideology, as it could be readily understood by a wider public, including illiterate farmers and laborers. Artists were trained to serve the revolutionary cause, and depictions of the human figure were the most effective vehicle to convey ideological messages: heroes of the revolution were portrayed so they could be emulated, while scenes of human suffering and social injustice showed the evils of the old society and the imperialists. The social and political environment offered no choice. Some artists continued to thrive even under the prescribed conditions, and later, when China's cultural atmosphere became freer in the late 1970s and early 1980s, those who were gifted and strong eventually asserted their independence and found their true artistic identity.

It is remarkable to see the variety of works produced in recent years by the four women artists from China presented in this exhibition: Zhou Sicong, Zhao Xiuhuan, Nie Ou, and Yang Yanping. Despite the external control the government imposed on them, they have each responded differently and have emerged with their own personal artistic vision and style. Their paintings have developed in interesting directions that often not only reflect the sources of their new inspiration but also reveal how they have assimilated their past experience into their creative work.

In many aspects, **Zhou Sicong** is representative of a whole generation of contemporary Chinese artists, those sometimes called mid-generation artists now in their forties and fifties. (The four artists from China in this exhibition belong to this generation, ranging in age from forty-three to fifty-seven.) They shared many similar experiences in their social circumstances caused by the political vicissitudes of China since 1949, and they were all trained to depict politically oriented pictures in the early stages of their careers. In its content, Zhou Sicong's *The Abandoned* (Plate 61), part of the *Miners* series of six paintings that portray the sufferings of laborers in China's northeast during the Japanese invasion, is an example of the ideological type of pictures the regime advocated. A melodramatic painting combining the styles of socialist realism and German expressionism (Zhou Sicong acknowledges the influence of Käthe Kollwitz), *The Abandoned* was done in part with her husband, Lu Chen, also a noted artist. In style the painting—executed in 1981 with Chinese ink and brush—differs from the

direct and straightforward realism that prevailed during the 1960s and 1970s. In *The Abandoned,* Zhou Sicong distorts figures to make them more expressive, and juxtaposes and scatters them all over the flat picture plane. Time and space become dislocated. There is no reference to a specific time, place, or event—"a moment in reality" that was a standard formula in the popular socialist-realist paintings of the 1960s and 1970s.

Instead, this is a composite picture, incorporating fractured segments of visual phenomenon. The fragmentation of imagery and superimposed elements evident in the composition suggest the artist has transcended time and space to create a symbolic reality—a reality compressed to symbolize the universal human condition of suffering, in which pain and anguish are intensified. This highly schematic and emotionally charged picture embodies the personal view of the artist—her inner response to the hardships of the workers she had visited at the mines in northeast China. (She had gone there to do preliminary sketches.) The painting goes beyond mere representation, for the artist has discarded the logic of realism and the conventional socialist-realist formula to create her subjective reality. Her ideas, emotion, intellect, and artistic sensibility have prevailed over the observing eye. The long-suppressed individualistic will has surfaced.

The *Miners* series of paintings mark a significant change in Zhou Sicong's style and artistic development as well as indicate the political and social changes that occurred in China after the Cultural Revolution ended in 1976. Traditional art forms were revived and artists were permitted relative freedom to experiment. China was slowly opening its doors to the outside world. Even then, Zhou Sicong's *Miners* paintings, which departed from the earlier style of realism that had gained her renown in China's art establishment, were criticized and considered by many to be a failure.

In a recent interview, Zhou Sicong discussed the circumstances of the time.[4] She had begun to feel a need to change her style, and her old method of realism could no longer serve her artistic purpose. She had already experienced this very strong urge within her when she painted her famous portrait *Zhou Enlai and the People* in 1978. In portraying China's revered Premier Zhou, she did not dare to experiment but followed the same conventional methods she had been using, for fear that she would be criticized for being disrespectful toward China's leadership. By the time she began her *Miners* series, which took three years to complete, 1980 to 1983, she felt her earlier style was simply inadequate to express her mixed emotions.

"It was necessary to change my style—to distort and exaggerate the figures of the miners. Without the distortion, I could not express the feeling of oppression in the painting. My composition also had to change; I could no longer use the old method that only captures a moment in reality. It was all done out of an inner need," she explained. "Many people said I had failed in my *Miners* paintings—that I, who had such a good foundation in art, had become sloppy. Those who supported me were mostly oil painters. At the time, I replied that even if I had failed, I had to change my artistic direction, that I could not continue to do the same old thing. Two years later, when my *Miners* paintings were exhibited, people gradually became accustomed to them. Today, looking at the paintings, people do not see anything special about them—there is nothing so special for them to criticize after all."

Zhou Sicong candidly discussed the constraints of the formal training she received at the Central Art Academy in Beijing, pointing out that the rules and training methods were sometimes too rigid and restrictive. "Some teachers say one should paint slowly, in order to retain the flavor of the brushline. Others say one should paint quickly, or else the spontaneity will be lost. I think there is no set rule. I have used the teachings to guide my work, but I have found they have also given me restraints. Those who have not received training at the art academy are much freer, but for them it is easy to go the wrong way without the fundamentals," she said. "One really cannot blame the art academy. Many have stayed in it too long. Their techniques are good, but they simply have no feeling for art—they are just not suited to being artists. However, look at Li Keran—how he passionately loved nature—he really had the true spirit of an artist! There are things an art academy just cannot teach."

Zhou Sicong was fortunate to receive a solid art education. Unlike some younger artists whose education was interrupted by the Cultural Revolution, she studied Western art methods during middle school from 1955 to 1957, and in 1958—when she was nineteen—entered the Central Art Academy to learn traditional Chinese painting (*guohua*). Her teachers included such eminent artists as Li Keran, Li Kuchan, Ye Qianyu, Liu Lingcang, and Jiang Zhaohe. Her good foundation in art and mastery of descriptive realism are manifested in a series of figure studies (Plates 58–60) she did in 1980 in preparation for the *Miners* paintings as well as in her drawings of the Yi minority people (Plates 54–57) done in 1981 during a trip to Sichuan Province. Her artistic focus shifts from representational realism to semiabstraction in her drawings of nudes (Plates 52–53) of 1985, which through her deftly drawn contour lines capture a feeling of coarse beauty and heaviness in the figures, without any use of shading or modeling. Her paintings since 1985 (Plates 47–51), are mostly done in the sketchy *xieyi* ("idea-writing") or *pomo* (splashed-ink) manner, evincing a new freedom and spontaneity entirely unlike her earlier works. She began to explore new directions in her art in 1985, but unfortunately developed arthritis, which has affected her creative work. These days she paints at intervals, when the pain is not too severe.

Is Zhou Sicong's art a part of the new stylistic trends developing in China today? Some Chinese critics have referred to the "new literati painting" in contemporary Chinese art. Is that the path Zhou Sicong has taken? She responds that she simply follows the natural course. She is a product of her time and experiences, she says, and can only go her own way, at her own pace. With the type of education she received and having been so restricted for so many years, she cannot follow the rapidly changing trends of the younger generation. Like a woman with bound feet whose bonds have suddenly become untied, she—like others of her generation—cannot be expected to take leaps.

"But our special experiences have given us our special character, something that will not be seen in the younger generation," she said. Viewers of her paintings frequently find the mood melancholy and disenchanted, according to Zhou Sicong. Some critics of her work have also mentioned this quality, but she said this is not what she intentionally wishes to express. Perhaps the melancholy derives from her life experience and her bouts of illness—and that is her special character, contained within the private world of her painting.

Zhao Xiuhuan, like Zhou Sicong and other mid-generation artists, was also trained to depict ideological pictures. Partly reacting against the propagandistic use of the human figure in art, she later turned to the bird-and-flower theme, which has now become her specialty (Plates 40–46.) This shift did not happen until 1976, three years after she was appointed to the Beijing Painting Academy in 1973 as a professional artist. "That was very fortunate for me," Zhao Xiuhuan said of her appointment, which was decided by China's cultural authorities.[5] She had attended the Central Art Academy Middle School for only two years, from 1964 to 1966 (the normal course for graduation being four years), when the chaos of the Cultural Revolution interrupted all activities. In 1969 she was sent to work at a farm in northern Hebei Province and did not return to Beijing until 1972. That year she married, at the age of twenty-six. It was an unhappy marriage that was finally dissolved many years later. "At the time, I only cared about survival," she said. Members of her family had been tragically killed; marriage to a worker with whom she shared no common interest at least provided a livelihood.

Her appointment to the Beijing Painting Academy allowed her to pursue art again and the stipend provided by the Academy enabled her to gain some independence. Unlike the Central Art Academy, which is devoted to art instruction, the Beijing Painting Academy is composed of professional artists who devote their time to painting and independent study. Zhao Xiuhuan would have entered the Central Art Academy to continue her education, but that institution did not resume classes until 1978. Graduates of the Central Art Academy are often assigned to the Beijing Painting Academy (for example, Zhou Sicong and Nie Ou), while others are sometimes appointed to the faculty of the Central Art Academy. Through affiliation with these institutions, artists receive their stipends and are assigned studios and living quarters, usually located near the academies.

Zhao Xiuhuan had learned only Western art methods in her preparatory training at the Central Art Academy Middle School and had no experience with traditional Chinese ink-and-brush techniques. At the Beijing Painting Academy she was surprised, she recalls, to see the older, traditional artists painting without models, not from life or nature, but from memories, intuition, and past experience. With their ink and brush they created rocks, mountains, trees—and an entire landscape came into being. To learn traditional Chinese styles posed a challenge for Zhao Xiuhuan and she was excited by the prospects. As China's political atmosphere had become more relaxed and stable, many older, traditional artists had returned to the Academy to paint. Among them was Pan Jieci, whose work she admired, and she began to study under him independently. He was skilled in *gongbi hua,* a style of painting sometimes called the meticulous method of descriptive realism, noted for its use of precise lines and brilliant colors. This style flourished during the eighth century of the Tang dynasty and may be seen in many Buddhist figure paintings. Zhao Xiuhuan assiduously copied the famous *Eighty-seven Immortals* scroll over and over again, in an effort to master the fine-line tradition and the control of ink and brush.[6] Mr. Pan's guidance and the rigorous method of copying ancient masterpieces, part of the training for a traditional-style artist, gave her a good solid background. But she was soon tired of painting ancient figures and historical themes remote from her personal feelings. Her earlier training in depicting the human figure for political purposes had also engendered her aversion for figure painting.

Zhao Xiuhuan's artistic interests took a new turn in 1976. Through her friendship with Peng Peiquan, a bird-and-flower artist at the Academy, and the experience of viewing exhibitions of famous paintings of bird-and-flower themes at the just-reopened Palace Museum, she became fascinated by this genre. The expressive power of flower paintings by such famous artists as Ren Bonian, Wu Changshi, Xu Gu, and Zhao Mengchien moved her. Their dextrous use of the brush, ink play, and the poetic and philosophical emotions expressed in their paintings, she felt, elevated their art to a spiritual realm that she aspired to attain. The beauty of the flowers also offered her an escape from everyday realities, so she sought refuge in her art and began her experiments to create her own style of flower paintings.

When Zhao Xiuhuan's flower paintings were first introduced to American viewers in the exhibition "Contemporary Chinese Painting,"[7] which toured the country from 1983 to 1985, she had already found her own style. The sheer visual beauty of her two paintings *Clear Spring* (1981) and *Mountain Stream* (1982) in that exhibition captivated the attention of many viewers and critics. In these two paintings, bluish and lavender blossoms and foliage are depicted with meticulous accuracy against a dark background of rocks and a running stream. Both works clearly demonstrate her technical excellence in the *gongbi* manner. *Mountain Stream* in particular possesses an indefinable spiritual—almost ethereal—quality, an enigmatic aura tinged with melancholy and lyricism. The surrealistic glow that seems to emanate from within the foliage heightens the feeling of mystery. *Clear Spring* has a more decorative appeal: brilliantly colored flowers and leaves are dramatically juxtaposed with the dark, overlapping rocks rendered in large, rounded abstract forms.

Unlike traditional *gongbi* bird-and-flower painters, who portrayed their subject matter against a blank background, Zhao Xiuhuan created a natural setting for the flowers, as though she was painting a landscape. The setting, however, is abstracted nature, an idealized landscape composed of only rocks and stream that she uses often, almost like a formula, for many of her flower paintings done in the early 1980s. This style may be seen in *New Spring* (Plate 40) in this exhibition, which was done in 1990 as a special effort to recapture her earlier style. The rocks, like a stage prop, serve as a backdrop for the flowers, again painted with realistic details and alluring colors; it is a well-designed, formal, and arbitrary relationship, with no sense of naturalistic scale or atmosphere. Combining elements of realism and abstraction, Zhao Xiuhuan has contrived her own natural world—a world of order and perfection, imbued with a romantic ambiance and a sense of mystery, as if of nostalgia.

In her artistic explorations, Zhao Xiuhuan has progressed from flowers-with-setting to "portraits" of flowers, as may be seen in her more recent works (Plates 42–45). The compositions are simplified: close-up views of flowers and leaves depicted against an abstract background of modulated hues. Her colors are rich but subdued and somber in tone, primarily greens and blues (Plates 41 and 45). The palette is occasionally lightened by the use of brighter colors such as yellow (Plate 44) and touches of white (Plates 42 and 43). The aura of mystery lingers in these paintings, and the mood is usually pensive and detached. Though elusive, these images are eloquent expressions of the artist's quest for beauty and an idealized reality, which she finds in nature.

Zhao Xiuhuan has strived to incorporate her training in Western art into her traditional Chinese bird-and-

flower paintings. In her earlier style, it is evident she was attempting to achieve a sense of depth and three-dimensional space through the use of overlapping rocks, and shading may be detected in her renderings of the flowers and leaves. These elements of Western realism are more pronounced and visible in her recent paintings. There is a stronger contrast of light and shadow; the colors are now more diffused and the outline of the images is softened, although she still employs the *gongbi* fine-line style. The tonal gradations are more subtle and varied, creating nuances of space and depth, light and shadow. In spite of the realistic details, the overall effect has an abstract, impressionistic quality. These qualities are best seen in her magnificent close-up view of *Green Lotuses* (Plate 41), in which the delicate interplay of green and bluish hues is enhanced by the gentle rhythm of the undulating lotus leaves to create a painting of remarkable abstract beauty. In spirit, *Green Lotuses* is much bolder, freer, and more spontaneous than her other paintings. It seems to indicate a new direction in her development.

Fundamentally, Zhao Xiuhuan is a painter of realism. Her approach is Western: she sketches from nature, as may be seen in her album of pen-and-ink flower studies (Plate 46) in the exhibition, and all her paintings are based on her sketches. But she uses traditional Chinese ink, colors, and brush as her media to accomplish the effects evinced in her painting—the transformation of realism into abstract feeling. There are very few good *gongbi* artists in China today, perhaps because younger artists do not have the patience to practice this very time-consuming method of descriptive realism.[8] Not only is she accomplished in the *gongbi* style, but she has brought the ancient tradition of *gongbi* flower painting into the twentieth century with her infusion of modern, abstract feeling. Zhao Xiuhuan acknowledges that she has been more and more influenced by Western painting since she came to the United States in 1989, having had the opportunity to see more Western art in museums and publications. Her new environment has also affected her work: the bright sunlight of California, where she now resides, and the variety of flowers she sees in this country have given her a fresh vision.

Nie Ou, two years younger than Zhao Xiuhuan, also had her education interrupted during the Cultural Revolution in 1969, when, at the age of twenty-one, she was sent to a farm near Datong in northern Shanxi Province.[9] Earlier, from 1960 to 1966, she had studied art on weekends at the Youth Palace (Municipal Children's Center) in Beijing, which offered Western art curriculum similar to that of the Central Art Academy Middle School. In spite of the hardships at the farm in Shanxi, known as the loess country of China and characterized by its harsh winters, she seemed to endure with good spirits and was able to continue drawing and sketching.

"The work was hard, the food coarse, but we were young," she said.[10] For several years she shared the life of the peasants in the small village, setting off for work at sunrise and returning at sunset, her body exhausted and barely able to move as she collapsed on the earthen bed. To her, it was a life of bewilderment, of waiting; sometimes there was joy, and sometimes tears. Inexplicably, she said, her frame of mind was sanguine, tranquil, and even cheerful at times.

She found beauty in the loess plateau—the morning mist rising, the white frost of winter covering the earth and the roofs, the sun hovering over the hills, the golden autumn ushering in the harvests, and the falling leaves

dancing in the air. The peasants were good to her and the others in her group of twelve educated youths sent from Beijing. They liked her drawings and sketches, and often sat as models for her portraits. She sketched the animals at the farm, the villagers and their activities, the houses, trees, rivers, and the natural environment she saw—much of which became the themes of her later paintings. She did posters for the communes, and some of her oil paintings were even presented in the provincial exhibitions.

After three or four years, she was summoned back to Beijing. It was not until 1978, however, that the Central Art Academy resumed classes, and she—though nervous—successfully passed the qualifying examinations to enter the Academy's graduate department. She chose to specialize in traditional Chinese painting methods, an entirely new area for her, and studied mainly with Lu Chen (the artist-husband of Zhou Sicong). Two years later, at the age of thirty-two, she graduated and was assigned to the Beijing Painting Academy as a professional artist.

Nie Ou first gained recognition in 1982 with her painting *Dew* (Plate 26), which won a prize in a Beijing art competition and was subsequently included in the contemporary Chinese painting exhibition presented in the United States from 1983 to 1985.[11] Her subject matter of workers and peasants and her style represented something new in traditional-style Chinese painting, which had just been revived in the late 1970s. Although painted with traditional Chinese ink and brush, the picture strongly resembled Western charcoal drawing and was characterized by Western naturalism. Nie Ou was one of the youngest artists represented in that exhibition. In her style of the early 1980s, she strived for visual accuracy and adhered to observed reality. Some of her other works from this period are more complex and dense in composition, filled with more people—couples with children and families. Workers, peasants, farmers, villagers have always been her subject matter—the ordinary folks who fitted into the ideological framework of socialist art. The choice was a natural and inevitable outcome of her environment. As she herself said, "I only paint what I have seen and experienced. I had only been to the countryside, aside from the urban life in Beijing. My memories of the peasants and rural life always come back to me."

Nie Ou's early style demonstrates her skill in representational realism, with a predominantly Western flavor. Around 1985, however, her style began to change toward a more conceptual attitude. Since then, she has adopted the more abstract and sketchy *xieyi* style to depict images from nature, which she reconstructs in her painting. Her figure compositions are now more simplified and sparse, characterized by an economy of line and a reduction of forms. A terse line, usually broad and coarse but sometimes fine and thin, describes the figures; they are painted without naturalistic details or shading. A notable feature is that the figures, now smaller, are often integrated with landscape elements. Some examples may be seen in her paintings (Plates 21 to 24) and albums (Plates 16 to 20) in this exhibition, all of which date from 1987 to 1991. The shift from an objective reality to an abstracted reality is exemplified by two rare landscapes, dated to 1985 and 1986 (Plates 14 and 15): the huts, stubby trees, sun and moon hovering over the hills—some of her recurring motifs—are reduced to their basic essentials, painted with ink-and-color washes without outline against a vast expanse of empty space. These constitute the idea of a landscape, reconstructed from memories, intuition, and past experience. She

paints these in her studio, not from life or from sketches.

Nie Ou's paintings since 1985 have become more Chinese, less Western. Like traditional Chinese paintings, they are now a distillation of reality, evoking a generalized feeling, a concept rather than a temporal phenomenon or a transient "moment of reality" that Western realism aims to capture. Ironically, in 1985, at a time when Chinese art circles were heatedly discussing art, and many artists were turning to Western art for new directions and innovative techniques, Nie Ou—out of her own needs and because she has always harbored a distaste for fashionable trends—began instead to delve into traditional Chinese art.

Like many others of her generation, Nie Ou had disliked traditional Chinese painting, and she was surprised to discover the infinite wonder and depth of the ancient masters. The seventeenth-century individualist Shitao, in particular, excited her. His conception of nature and artful manner of re-creating the world moved her deeply. She sensed the freedom of spirit in his painting and, to her, he was painting the hills and vales within his heart and not what he saw in the real world. She felt that his art exuded a modern, yet antique, feeling and, although his paintings give an abstract impression, the details are realistically accurate. "Looking at his art," she said, "one forgets oneself and seems to rise above the mundane reality of the everyday world." While feeling greatly liberated, she also became conscious of her inadequacy as she marveled at the accomplishments of China's ancient masters. Slowly she began to copy Shitao's works, not the entire painting but individual motifs—a tree here, a stone there. She was copying the ancient techniques, not the style of the painting, which she then applied to her own compositions.

Nie Ou's recent paintings reveal her personality; they are characterized by wit and humor, a fresh and direct outlook, a keen sensitivity to details, and a sense of wonder and innocence. These qualities are best seen in her small albums of continuous narratives depicted like handscrolls (Plates 16–20): they are vivid, delightful scenes of village life in which a relaxed and tranquil atmosphere prevails. The figures weave in and out of the landscapes in which the abstracted natural elements—the cubistic rocks, for example—are positioned in a manner that suggests near and far distance, perspective, and a sense of three-dimensional space (Plates 16, 17, and 20). Distinguished by their posture and attire, the figures are gathering wood, weaving baskets, carrying stacks of hay, or idling their time away napping, drinking, playing with the children, or just resting on the ground. Children play a dominant role in Nie Ou's world, and she shows a fondness for animals, especially donkeys.

Her narrative albums are varied and filled with charm and imaginative details. They are down-to-earth scenes of humanity permeated with a sense of kinship and warmth. Touches of vibrant colors—red, yellow, blue, green, purple—which the artist has been using more and more in recent years, enliven the mood and give the paintings a decorative flair. These narrative scenes are created from her mind, and she attributes her experience in book illustration as a source of inspiration.

Two tiny albums in this exhibition demonstrate Nie Ou's technical virtuosity and adroit characterization of figures. One album depicts figures in landscape and the other figures set against an empty background (Plates

18 and 19). In the latter, in which villagers are enjoying the pleasure of wine, she has created a panorama of colorful characters, each one individualized by facial expression and varying posture, on a narrow strip of paper measuring only four-and-a-half inches high. Intoxicated, one man gesticulates wildly, while an old man leaning on a cane looks on drowsily. These earthy peasants rendered on a small scale assume the monumentality and grandeur of figures seen in early Chinese pictorial art, such as the Han murals of the first and second centuries. Perhaps Nie Ou, who had experienced the blending of modern and antique feelings in Shitao's art, intends to evoke the spirit of antiquity in these contemporary scenes? Here, she delineates the figures with a finely drawn line—a line similar to the "silk-thread" line seen in Han art. Her aim to capture the feeling of antiquity is clear in her larger album, *Mountain Villagers* (Plate 20). Having been influenced by China's ancient masters, she now uses the traditional Chinese *cun* brush stroke to define the texture and form of rocks and hills in the landscape scenes of this album, one of her definitive works in the exhibition. The result is a landscape environment reminiscent of ancient paintings but inhabited by contemporary people—the peasants and villagers of modern-day China, instead of the literati scholars seen in the ancient paintings. In her synthesis of realism and abstraction, tradition and innovation, past and present, Nie Ou has transformed her art into a personal, unique vision.

An intelligent and open-minded person, Nie Ou—now only forty-three years old but already much acclaimed—continues to advance in her artistic career as more and more opportunities become available to her. Last year, together with her artist-husband, Sun Weimin, she visited Europe for four months—from September to December—traveling to Spain, France, Italy, and Switzerland. It was an exhilarating experience for her—looking at so much art in the museums and seeing the landscapes of those countries. Upon her return to Beijing, she felt inspired to paint in oils again. In *Autumn Scene outside Paris* (Plate 13) she reconstructs from memories the autumnal colors of the forest in an impressionistic scene of deep red hues, in which one of her distinctive motifs, the stubby tree, appears in the foreground. Her depiction of *A Chinese Village* (Plate 11) in a monochromatic, brownish palette captures the essence of the terrain of northern China, often barren and bleak but yet timeless and enduring. In contrast, *A Swiss Village* (Plate 12) shows an abundant growth of trees and exuberant colors. These oil paintings, showing a strong sense of color not seen in her traditional-style Chinese paintings, are another aspect of her achievements that this small exhibition can only suggest.

Yang Yanping, the oldest of the four women artists from the People's Republic represented in this exhibition, is also the most experimental and least traditional in her approach to art. Now fifty-seven, she resides in the United States with her husband, Zeng Shanqing, also an artist and at one time her teacher. They came to this country in 1986, when Yang Yanping was invited by the State University of New York at Stonybrook to be a visiting artist. Since then, she and her husband have participated in several exhibitions in Japan, Taiwan, Austria, Hong Kong, and the United States.

In the contemporary Chinese painting exhibition of 1983 to 1985, she was represented by a painting called *Towering Mountain,*[12] which showed her formalistic approach to art and her tendency toward abstraction, a trend then epitomized by Wu Guanzhong, who was also included in the exhibition but was at that time

relatively unknown, especially outside China.[13] In this painting, mountain forms are delineated into abstract areas of space, creating a very modernist feeling similar to contemporary Western art. Professor Michael Sullivan, a contributor to the catalog of that exhibition, considered that her "inspiration seems to be a new feeling for form, an inner vision, that owes little to influence either from the past or from abroad."[14] (Unlike Wu Guanzhong, who had studied in Paris, Yang Yanping had never been abroad until she came to this country in 1986.) In reviewing the exhibition, the *New York Times* art critic Michael Brenson referred to her painting as approaching "abstraction in a way that brings to mind Milton Avery."[15]

Towering Mountain indicated a new and unorthodox style in traditional-style Chinese painting and for that reason was selected for that exhibition, which was intended as an overview. To trace Yang Yanping's artistic evolution is difficult: her repertoire is rather limited, not much has been published about her, and many of her earlier works remain in China. By her own account, she was largely self-taught as an artist, but benefited from the advice of many friends and teachers.[16] She studied architecture at Qinghua University in Beijing. There, as part of the curriculum, she received basic instruction in art, such as life-drawing and sketching, from several teachers, including Wu Guanzhong and Zeng Shanqing (who had studied under Xu Beihong).[17] After graduation in 1958, she worked at various jobs related to architecture and construction and, in her spare time, began to paint in oils—landscapes, figures, and portraits. During the Cultural Revolution, in 1966, she was assigned to be an art worker at the Industrial Art Design Department of the Beijing Art Agency. In 1968 she was transferred to its Oil Painting Department, where she painted portraits of national heroes and panoramic landscapes that decorated public buildings. In 1976, she was assigned to work at the Chinese National History Museum, where her responsibilities included administrative duties as well as oil painting. At this time she became interested in traditional Chinese ink-and-brush methods and began to paint *guohua* independently during her free time. She used the *baimiao* ink-outline style to depict figures and landscapes, her paintings from 1978 to 1981 being mostly pure line drawings with light colors. Then, from 1981 to 1983, she painted many calligraphic works: pictographic images composed of Chinese calligraphic motifs with an emphasis on form and structure.[18] In 1981 she began her series of lotus paintings as well as her landscapes of rocks and snow scenes.

Today Yang Yanping is one of China's leading women artists and her innovative techniques and ideas are important in the context of developments in contemporary Chinese art. Her formalistic approach to art is best seen in her two landscapes *Rocks* (Plate 37) and *Mountains* (Plate 39) and to some extent, in her very large lotus painting *Winter Lotus Pond* (Plate 35), all undated but according to her executed around 1988 and 1989. In the two landscapes, she has transformed nature into nicely balanced images of geometric patterns—rounded, curvilinear, and triangular; they show her perceptive feeling for compositional logic and abstract design. In *Winter Lotus Pond*, she paints lotus leaves as large, amorphous forms that echo and repeat one another in an orchestrated interplay of abstract silhouettes, as if producing the rhythm of music in their harmony and resonance. The large lotus leaves are rendered in richly suffused ink washes of differing density, some dark and some gray, while the small deep purple lotus buds and the stems are drawn with precise calligraphic lines, acting as a foil to the hazy, impressionistic leaves that seem to float in space. A strong formal and spatial relationship underlies the

composition of these paintings, creating an overall effect of harmony, order, and coherence. She has carefully planned her pictorial scheme.

In her techniques, Yang Yanping uses the traditional Chinese brush in some areas, especially in delineating the forms with fine lines, but she has also employed nontraditional techniques such as crumpling the paper, random splashing of ink, and soaking or pressing inked paper on the painted surface—techniques that do not require the use of the brush. These techniques have been used by several noted artists outside China, among them Liu Guosung and Wang Jiquan (C. C. Wang),[19] and they have been carried to extremes in some cases by younger artists in China who responded too enthusiastically to outside influences. Yang Yanping is cautious to point out that she uses these techniques not for their own sake but to achieve certain pictorial effects. Her use of them, which began long before she came to this country, is moderate, since she still relies mostly on the traditional Chinese brush in her painting. Basically, she said, her style has developed out of the Chinese tradition.

In the history of Chinese art, unorthodox techniques such as the splattering of ink were practiced as early as the twelfth century by the *Chan* Buddhist artists associated with the literati school in their search for new artistic freedom and spontaneity. The Yangzhou Eccentrics of the eighteenth century were known for their unconventional methods, such as painting with their fingernails. Even Li Kuchan, one of the innovators of twentieth-century Chinese painting, who died in 1983, experimented with pouring ink on the paper and dabbing on colors with a damp rag to achieve the loose, spontaneous, impressionistic effect seen in some of his big lotus paintings.[20] Yang Yanping's techniques may be new and unorthodox, but not her spirit of experimentation. When her efforts are successful, interesting fibrous textures of a multilayered, transparent quality enhance the pictorial surface and heighten the atmospheric effects of the ink tones and color washes. They also intensify the feeling of depth—visible, for instance, in *Rocks* and *Winter Lotus Pond* where background space is activated by variegated, stainlike effects. Partly because there is a random and accidental factor in these techniques, she is not always able to achieve satisfactory results and often tears up her work. This is not uncommon even among Chinese artists who paint only with the brush; they, too, often destroy many pieces of their work before achieving the final result.

Yang Yanping seems to be at her best when she uses muted colors, creating paintings that are very appealing visually—lyrical, poetic, and somewhat dreamlike. But appearance is not what she seeks in art. For her, the lotuses embody her philosophy of life: they symbolize the transience of time and the fragility of nature. The seasonal cycles of the lotuses she paints are visual metaphors for the different stages of life. She claims indebtedness to the literati theory of art, which influenced her and led her to seek expressiveness and not representation. Her lotus paintings serve to express her feelings about life and its impermanence. For the past few years, she has focused on the lotus and the rock or mountain landscape as themes, which she composes from her memory and imagination, without ever relying on sketches.

A salient feature of Yang Yanping's art is her strong sense of space and design. Her feeling for form may be partly innate but may also stem from her training in architecture. That she is largely self-taught as a painter

perhaps explains her freedom and boldness in trying new techniques. Above all, as a well-educated woman with a mind of her own, she is not afraid to explore new artistic directions or to take risks.

Like Zhao Xiuhuan and other expatriate Chinese artists now living in the United States, Yang Yanping enjoys the intellectual freedom, which offers the stability to create art independently without fear of political criticism as in China. But there are disadvantages as well, which distract from their ability to pursue art and often disrupt the careers of many expatriate artists. The economic pressures and competitiveness they have experienced in this country are difficult for them to cope with. In China, professional artists such as Zhao Xiuhuan and Yang Yanping, both affiliated with the Beijing Painting Academy, receive a stipend for their expenses and are paid percentages for the paintings they sell through official channels; they are also assigned living quarters and studios that they can keep for their entire lifetimes. The stipends are barely sufficient, however, and cannot be used to purchase certain goods that require foreign-exchange currencies. The living quarters and the studios are usually small and cramped, often without heating and the material necessities of the West. (The size and condition of these accommodations are determined by the status of the artists, so that older, established artists fare much better, especially those with official connections, who frequently pass on their apartments to their children when they move to better quarters or when they die.) In spite of the numerous constraints, professional artists in China are at least able to devote their time to their painting and their artistic careers. In the United States, many expatriate Chinese artists turn to other means of livelihood for their economic survival; some teach Chinese painting but feel they do not have enough time for creative work or, if their paintings do sell, they are under constant pressure to produce for the commercial galleries and may eventually lose sight of their artistic goals. Those unable to speak or write English often suffer a tremendous sense of loneliness and isolation. For these and other reasons, Chinese expatriate artists in this country often feel ambivalent about whether to stay or to return to China.

In adjusting to their new lives in the United States, both Zhao Xiuhuan and Yang Yanping have been sustained by their art, which they continue to pursue seriously. It is perhaps this dedication to art that has enabled them to surmount the many obstacles they have encountered in their lives and professions.

In the mid-1980s, the government of the People's Republic became more liberal in granting exit visas, and Chinese artists are now able to visit the West to see its art and meet its artists. Meanwhile, artists of Chinese background in Hong Kong, Taiwan, and other parts of Asia have been turning to the West for inspiration since 1949, when mainland China cut its ties to the rest of the world.[21] Although traditional-style painting has persisted, especially among the older generation, more and more Chinese artists living outside China have chosen Western media, painting in oil or acrylic on canvas, while others—though still using traditional Chinese ink-and-color methods—frequently employ unorthodox techniques in their search for new art forms and expressions. As a result, their styles often synthesize Eastern and Western elements, incorporating traditional Chinese art with new techniques influenced by modern Western art. For many, their links with traditional Chinese art become more and more tenuous as their experimentations become bolder and their styles more abstract.

The growing interest in contemporary Chinese art in recent years has encouraged an increasing number of exhibitions and publications devoted not only to mainland Chinese artists but also to Chinese artists living abroad. At the same time, a thriving contemporary art market has given impetus to this interest. Contemporary Chinese painting has become a serious area for collecting and for scholarly research. These factors contribute to a deeper awareness of the new trends developing among international Chinese artists living today and have also illuminated the achievements of some previously obscure artists.

A prevailing trend that has significantly influenced contemporary Chinese painting outside China is the unorthodox treatment of the pictorial surface, such as crumpling the paper before applying colors to create texture patterns, making repeated imprints on the paper by a stamping process similar to woodblock printing, soaking ink and colors through several layers of paper, or adding other components to the paper as in the collage technique. Artists use these techniques to enrich the pictorial surface in order to achieve greater expressive or decorative visual effects through an emphasis on texture. They are frequently coupled with the semirandom splashing of ink and colors on the paper, sometimes without the use of the brush; in such cases the results are abstract and expressive, akin to Western abstract expressionism, which is a source of influence. The techniques are varied, and some artists are more inventive than others. Yang Yanping, as discussed above, uses some of these techniques in her paintings, along with such well-known practitioners as Chen Qiquan, Liu Guosung, Wang Jiqian, and Zeng Yuhe (Tseng Yu-ho)[22]—all noted for their experience in traditional Chinese as well as Western art.

Nancy Chu Woo typifies a new generation of Hong Kong artists in her use of eclectic and versatile styles, which arise from her multicultural background and education.[23] Born in Guangdong Province, China, in 1941, she grew up in Hong Kong, where her family moved shortly after her birth. As a young student, she took private lessons in Chinese painting from the Lingnan master Zhao Shaoang, who has many followers in Hong Kong. The Lingnan school of painting originated in Canton and flourished in the early twentieth century, incorporating influences from Japan and the West into traditional Chinese painting.[24] The style is characterized by the sketchy use of brushwork and features of Western realism, such as atmospheric and light effects, shading, and perspective; in addition to landscapes, the bird-and-flower theme, usually depicted with brilliant colors, is a favorite among many Lingnan painters in Hong Kong.

With this early foundation in traditional Chinese ink-and-brush method, Nancy Chu Woo left Hong Kong to study fine arts in the United States in 1959, where she received a bachelor of fine arts degree from Cornell University and a master of arts degree from Columbia University in 1964. Her academic training in Western painting distinguishes her from many self-taught Hong Kong artists, especially women, who lack a formal art education and the discipline or opportunity to pursue art professionally. In this regard, she admits she has enjoyed certain privileges that have permitted her to concentrate on her artistic career, and she has used these privileges to broaden her knowledge of different types of art through her travels to view art in China, the United States, and throughout Europe. Her paintings are sophisticated and international in character, reflecting the

multicultural forces that have shaped her outlook and influenced her styles. After a sojourn of about ten years in New York City, from 1964 to 1973, she returned to Hong Kong with her husband, whom she had met at Cornell. They have raised a family in Hong Kong, where she continues to paint and to teach part-time at the University of Hong Kong. While she acknowledges the help and support given by her husband, a successful businessman, clearly it is through her own perseverance that her art has continued to develop and mature.

Nancy Chu Woo paints in oil on canvas as well as traditional-style Chinese landscapes in the Lingnan manner. In recent years she has preferred to use Chinese rice paper with coarse fiber because its high absorbency allows her to achieve the luminous effects of shimmering light and color in her impressionistic renderings of semi-abstract landscapes such as *Blue Cliffs* (Plate 29) and *Waterfall* (Plate 30). In these paintings, to capture the evanescence of nature, she crumpled some areas of the paper and then poured ink and gouache onto the pictorial surface, while guiding the flow of the colors with a brush. The crackled-ice texture she has created by crumpling the paper in *Waterfall* heightens a sense of atmospheric mists and cascading movement that is quite effective visually. (She is not so successful, however, when she uses these techniques to excess, especially in some of her abstract paintings, in which art becomes overwhelmed by technique.)

Nancy Chu Woo has a superb sense of color and form, which she adeptly integrates into her harmonious and well-balanced compositions. Her landscape *Blue Cliffs,* a pictorial realm of painterly blue tones, offers a temporal world of visual pleasure seldom experienced these days, when contemporary art often seems preoccupied with the morbid and the moribund. Her interest and skill in the expressive use of color is further demonstrated in her still-lifes *Mangosteens* (Plate 27) and *Two Peppers* (Plate 28) as well as *Seated Nude* (Plate 31). *Mangosteens* is a vibrant image of intense colors pulsating with energy, while *Two Peppers,* its colors more subdued and diffused, is no less evocative in its sensuousness—the peppers paired like two voluptuous nudes. The stylistic allusion to the nude forms seen in *Two Peppers* and her other paintings of the same subject recalls the photographic images of Edward Weston, in which the classic and abstract quality of "pepper" makes its specific and particular subject matter irrelevant.[25] In depicting the ephemeral and transient reality of this objective world, Nancy Chu Woo, at her best, hints at the underlying essence and the eternal—the abstract beauty at the core of all natural things sought by Chinese and Western artists alike.

By far one of the most interesting and original artists to have emerged on the contemporary art scene is **Irene Chou** (Zhou Luyun), who also lives in Hong Kong. Her abstract paintings explore new modes of expression and cosmic and metaphysical themes that are suggested in some of the titles, such as *Time and Space* (Plate 1), *Infinity I,* and *Infinity II* (Plates 5 and 6). But the titles are incidental, for many of her paintings are actually untitled. Often baffling, ambiguous, and paradoxical, her art hints at a spiritual realm for which there is no visual equivalent in the objective world. Her paintings are the untrammeled expression of her inner self—what she calls the "universe of my heart."[26] Her discovery of this inner self was a slow and arduous process.

Born in Shanghai in 1924, at a young age she learned Chinese calligraphy from her mother and music and art from her father; both her parents were radical intellectuals. According to her, her secondary education was

entirely westernized and her school, which emphasized art education, introduced her to Western paintings. At that time Shanghai was a cosmopolitan city where Western influence prevailed. Later, she studied economics at St. John's University in Shanghai, perhaps unconsciously repressing her desire to learn art or, as she said, she was then simply ignorant about life and what she wanted. A brief career as a journalist followed after she graduated in 1945, but was cut short in 1949, when, like many others, she immigrated to Hong Kong after the socialist government took control of China. There, she married and raised three children.

Irene Chou's gradual awakening to her inner needs occurred when, busy with household chores, she felt a void in her life and had the desire to paint. In the 1950s she began to study Chinese painting with Zhao Shaoang and Lu Shoukun, and it was Lu Shoukun who influenced her the most. An innovator in modern Chinese painting, Lu Shoukun was distinguished for his style of simplified compositions and spontaneous brushwork: his semiabstract landscapes are reminiscent of *Chan* (Zen) paintings, and he experimented with ink-and-color washes and calligraphic brushwork to produce abstract paintings.[27] Irene Chou learned to paint in the manner of her teachers and she also copied ancient paintings. As she admits, she had believed that art was imitation. During the process of imitation, however, she discovered the subtleties of ink and brush. Through painting she achieved a mood of tranquility and contentment and developed an interest in philosophy and religion. As her knowledge gradually broadened, she became more conscious of her inner aspirations, and what art and the creative process meant to her. More confident, she began to experiment on her own after she had acquired a basic mastery of painting techniques. The natural world stimulated her senses more acutely than before. She became more aware of different colors, of the ripples in the water as she crossed on the ferry from Kowloon to Hong Kong, and of the changing phases of the moon. As a longtime resident of Hong Kong, her direct experience of natural landscape, the subject matter of many Chinese paintings, has been very restricted. This is perhaps a key reason that her paintings have been introspective. But in her urban environment and within the confines of her studio, she experienced a new freedom as she applied different media—oil, acrylic, and watercolor—on Chinese rice paper and delighted in the dazzling new effects created. In the 1970s her artistic experiments led to many paintings using lines as the basic compositional elements;[28] for her, they were attempts to fuse her inner subjective world with the outer objective world through the expressive qualities of fluctuating linear rhythm. Later she devised her so-called "impact" texture stroke, achieved by the semirandom splattering of ink on the paper surface that produces highly abstract and rhythmic visual results.

In the 1970s, spurred by her early training in calligraphy, Irene Chou began to study the archaic calligraphic scripts inscribed on the bronze vessels of the Shang and Zhou dynasties, China's earliest historical periods (circa 1600–221 B.C.). These inscriptions have become a major influence on her art. "The boldness of the script, the elegance of the style, the novelty of the characters, and the sophistication of the strokes—these impressed me deeply," she said.[29] In calligraphy, China's oldest artistic tradition, also considered to be its most personal and expressive art form, she found purity of form and expression, which she has adapted and applied to her art. She now approaches calligraphy as abstract art, using its various forms and styles as a structural basis for the brushwork in her paintings.

Irene Chou's recent paintings show that she has evolved her own distinctive style, after developing through many phases that were documented in a retrospective exhibition held at the Fung Ping Shan Museum of the University of Hong Kong in 1986. Since then, she has become bolder, more confident, and even more innovative. After a period of hardships and depression following the death of her husband in 1978 (her teacher Lu Shoukun had died the previous year), she finally became the independent person that she is today. Since 1980, she has lived entirely on her own, having converted her apartment into a studio in order to concentrate on her painting. She practices *qigong* meditative exercises in the morning and paints in the afternoon. To be free, she avoids unnecessary social affairs and relationships. To some people who are more gregarious, she may seem like a recluse, but those who know her are impressed by her warmth and sincerity, her childlike innocence, and her lack of concern for worldly matters.

During the difficult times in the 1970s, she painted dark and oppressive pictures, which reflected her unhappiness. Since then, her new independence and freedom have changed her style. Her outlook on life is now more positive, at times even joyful and exuberant. There is a new vigor in her art, such as expressed in the paintings *Time and Space* (Plate 1), *Coda* (Plate 2), and *Abstract I* and *Abstract II* (Plates 3 and 4). *Time and Space* and *Coda*, in particular, convey a sense of immense power and movement; they are explosive, turbulent images of cosmic forces in flux, of transformations and metamorphosis. By comparison, *Infinity I* and *Infinity II* (Plates 5 and 6) are more tranquil in spirit, possessed of an ineffable, timeless quality that transcends the everyday and the incidental. The colors, textures, and calligraphic brushwork in these two paintings, so original in concept, offer an aesthetic experience of continual discovery, of infinite visual pleasure and emotional responses.

Irene Chou's calligraphic brush strokes are usually broad and powerful, but sometimes they are graceful, whimsical, and elegant, as in *Pastorale* (Plate 10) and in her several *Small Paintings* (Plates 7 and 8). Occasionally, her indebtedness to her teacher Lu Shoukun is visible, for example, in her use of broad slabs of ink in the painting *Positive and Negative* (Plate 9). In his later style of abstraction, Lu Shoukun often applied broad slabs of ink (rendered in a fashion recalling the abstract expressionist painter Franz Kline) in superimposed layers, creating a piled-ink architectonic effect that has a very direct, tactile feeling. In his abstract paintings, Lu Shoukun appears to be purely expressionistic, using ink-for-ink's sake as in art-for-art's sake. Irene Chou's abstract paintings and her expressive use of calligraphy are more complex, both in her methods of applying various types of brushwork and in her concepts, which sometimes suggest philosophical overtones. In a sense, her paintings are less simple and straightforward than Lu Shoukun's, and for that reason are perhaps not as easily appreciated. Highly subjective, they are the cumulative experience of an introspective mind.

Irene Chou paints from intuition and instinct, without preliminary sketches or planning. Her creative process is her art. In her *Small Paintings* (Plates 7 and 8), imagery she has used in the past frequently recurs, for example, the mask, the spiral, and the stylized plant. In executing these small paintings, she is more contemplative and less spontaneous; the effects are sometimes more decorative than expressive, achieved through her combination of intricate patterns, linear designs, calligraphic gestures, and the use of brilliant colors on shimmering

gold-flecked paper. At times, the labyrinthine structure and the convoluted spirals recall the ornamental sensuousness of the Austrian artist Fritz Hundertwasser. Created from the unconscious inner recesses of her mind, some of these recurring motifs perhaps have a symbolic reference. A leitmotif that appears often in her paintings is the sphere. To her, the sphere—a full circle and a perfect form—represents the ideal and the absolute, a spiritual reality of love and sincerity, of beauty and tranquility. There is no explicit meaning; for her it is a symbol that embodies the sublime and the spiritual forces capable of altering the course of the universe. She devised this symbol in her paintings of the 1980s after reading a poem by A. E. Housman on love and sincerity that moved her deeply. She has encapsulated her responses to the poem in the image of the sphere—or the circle, the ball— an image of wish-fulfillment, of romantic longings, of mystical escape that remains always stable and serene in the midst of fluctuations and turmoil.

Irene Chou's art epitomizes the spiritual reality sought by Chinese artists throughout the centuries. Yet in her abstraction she is unlike traditional Chinese artists who have always adhered to representational elements no matter how abstract their paintings appear. In spite of affinities with Western abstract expressionism, which may have influenced her work (she is well-informed about international art movements), the sources of influence in her stylistic evolution are primarily indigenous Chinese—essentially Chinese calligraphy and *Chan* (Zen) Buddhist philosophy. Oriental calligraphy and Zen paintings, in fact, have considerably influenced Western abstract expressionism, as its practitioners have expounded in their theories—Robert Motherwell, for example.[30] Is Irene Chou's art Chinese calligraphic abstraction or is it Western abstract expressionism? Perhaps it defies categorization. Nevertheless, the fusion of stylistic trends suggests that multicultural influences in contemporary art have gradually merged Eastern and Western art into an international idiom devoid of cultural barriers.

The art of Irene Chou represents an apex in contemporary Chinese painting. In her abstract paintings of universal appeal, she belongs to the contemporary international art world, an artist of accomplished techniques and refined sensibilities. Now seventy, she has produced a significant corpus of works that will undoubtedly have an enduring impact on contemporary Chinese art—and perhaps even contemporary Western art. In her artistic evolution and her self-discovery, Irene Chou is an exemplar of the artists in this exhibition—indeed, of all artists: their visions of reality, however they interpret them in their art, are ultimately reflections of their quests for artistic identity and expression.

Notes

1. For a thorough discussion of the changes brought about by the socialist regime and the Cultural Revolution, see Jonathan D. Spence, *The Search for Modern China,* especially chapters 19–21.

2. Susan Bush's *The Chinese Literati on Painting* provides a scholarly account of literati painting, its views and adherents, from the Northern Sung to the Ming dynasties.

3. Information on the artists' early training and the new art school curriculum, especially the preparatory school, is based mostly on interviews with the artists. In his introductory chapter, Chu-tsing Li in *Trends in Modern Chinese Painting* discusses the "art schools," which however refer to the more advanced art academies that offer both traditional Chinese and Western art training.

4. I interviewed Zhou Sicong in the course of organizing this exhibition. The comments quoted here are derived from my meeting with her and from the articles by Lang Shaojun and Gu Chengfeng published in the *Jiangsu huakan* 121 (January 1991): 15–22.

5. Zhao Xiuhuan came to the United States in 1989 and has been living near San Francisco for the past two years. Through more frequent contacts made possible by living nearer to her, I have come to understand her art and her personality better than when I first met her and saw her paintings in Beijing in 1982.

6. A famous figure painting by Wu Zhongyuan, who died in 1050, rendered in the fine-line *baimiao* tradition.

7. "Contemporary Chinese Painting: An Exhibition from the People's Republic of China" was organized by the Chinese Culture Center of San Francisco, in association with the Chinese Artists' Association of the People's Republic of China. I was executive director of the Center and curator of the exhibition. Professor James Cahill and Professor Michael Sullivan were invited to serve as art advisors to the project and both contributed essays to the catalog which, along with my introductory essay, provided an overview of the revival of traditional-style Chinese painting after the Cultural Revolution ended in China. The exhibition was composed of sixty-six works by thirty-six artists. After opening at the Chinese Culture Center in San Francisco in 1983, it went on a national tour from 1984 to 1985 to the Birmingham Museum of Art, Asia Art Society Gallery, Herbert F. Johnson Museum of Art (Cornell University), Denver Art Museum, Indianapolis Museum of Art, Nelson-Atkins Museum of Art, and the University Art Museum of the University of Minnesota at Minneapolis.

Zhao Xiuhuan's two paintings *Clear Spring* and *Mountain Stream* were illustrated in plates 60 and 61 respectively in that catalog.

8. One of them is Jiang Hongwei, noted for his bird-and-flower paintings that have been published by Rongbaozhai.

9. My discussion on Nie Ou, an artist I have known since 1982, is based on conversations with her and on viewing her paintings in Beijing during my trips to China as well as on various publications, especially the recent publication by Sichuan Art Publishing House and the Menam Hotel Co. Ltd. entitled *The Life and Work of Nie Ou* (in both Chinese and English), part of the Contemporary Chinese Artists series in fifteen volumes.

10. See "Nie Ou's Own Story" in *The Life and Work of Nie Ou* (unpaginated) from which all her quotations in this essay are taken.

11. See James Cahill, Michael Sullivan, and Lucy Lim, *Contemporary Chinese Painting: An Exhibition from the People's Republic of China* (San Francisco, 1983). Her painting *Dew* was illustrated in plate 31 of that exhibition catalog.

12. Illustrated in plate 53 of that exhibition catalog and on the cover of *Art International* 27, no. 3 (August 1984) for an article I wrote on that exhibition.

13. The formalistic basis of Wu Guanzhong's art and his stylistic evolution have been explored in a recent one-man show devoted to him, which I organized for presentation at the Chinese Culture Center of San Francisco in 1989. The exhibition later toured four other cities throughout the United States. It was accompanied by a fully illustrated catalog with essays contributed by several scholars. See Lucy Lim, ed. *Wu Guanzhong, A Contemporary Chinese Artist.*

14. Cahill, Sullivan, and Lim, *Contemporary Chinese Painting,* p.33.

15. *New York Times,* June 22, 1984.

16. I met Yang Yanping in Beijing in 1983, when I was organizing the "Contemporary Chinese Painting" exhibition, and there has been brief communication at intervals since she came to the United States in 1986. But my discussion of her background and the works in this essay is based mostly on my meeting with her at her home near Stonybrook earlier this year and subsequent telephone conversations and correspondence.

17. Xu Beihong played a vital role in introducing Western realism to modern Chinese painting in the early twentieth century; he had spent a long period abroad studying Western art. For an introductory account of this important artist, see Chu-tsing Li, *Trends in Modern Chinese Painting,* pp. 91–98.

18. These are discussed by Michael Sullivan in "The Calligraphic Works of Yang Yanping," *Apollo* 23, no. 291 (May 1986): 346–49. An example is illustrated in Michael Sullivan's *The Meeting of Eastern and Western Art,* p. 205, plate 133.

Several contemporary Chinese artists have experimented with calligraphic paintings. One of the most successful is Wang Fangyu, a Chinese scholar and artist living in the United States, whose beautiful calligraphic paintings have been widely exhibited and published. In style they are very different from the calligraphic works of Yang Yanping.

19. See *Paintings by Liu Kuo-sung* (Liu Guosong), exhibition catalog of the Taipei Fine Arts Museum; James Cahill, *C. C. Wang: Landscape Paintings;* and Jerome Silbergeld, *Mind Landscapes: The Paintings of C. C. Wang.* Chu-tsing Li's *Trends in Modern Chinese Painting* has brief, useful discussions of these two artists in the chapter, "A Turn to the West."

20. This is documented in a Chinese film on the artist that was shown to me by the Chinese Artists' Association in 1982, one of a series of films devoted to contemporary Chinese artists. When I met Li Kuchan in 1982, while organizing the "Contemporary Chinese Painting" exhibition, he discussed his methods and showed me his paintings in his home. He is known for his bold paintings of lotuses, birds, fishes, and vegetables, many of which are reproduced in Chinese art books.

21. For more information on some of these Chinese artists living abroad in Asia, Europe, and the United States, see Chu-tsing Li's *Trends in Modern Chinese Painting,* chapters 6, 7, and 9, as well as Michael Sullivan's *The Meeting of Eastern and Western Art.*

22. Lo Shan Tang has published a number of Chen Qiquan's paintings in their Contemporary Chinese Paintings series, volumes 1 to 3. A retrospective exhibition celebrating this artist's seventieth birthday opened on September 28, 1991, at the Taipei Fine Arts Museum.

On Zeng Yuhe (Tseng Yu-ho), see Howard A. Link, *The Art of Tseng Yuho,* Honolulu Academy of Arts exhibition catalog (Honolulu, 1987). I had invited her to participate in this exhibition but this well-known scholar and artist is in the midst of preparing for her 1992 one-person exhibition in Asia and assisting with a Ming furniture exhibition to be held in Beijing in honor of her late husband, Dr. Gustav Ecke, an Orientalist and art historian.

See note 19 for publications on Liu Guosong and Wang Jiqian. Several of these Western-influenced artists are discussed by Michael Sullivan in *The Meeting of Eastern and Western Art.*

23. More examples of her paintings may be seen in the recent Plum Blossoms (Int'l.) Ltd. exhibition catalog entitled *Chromatic Visions: Nancy Chu Woo,* which has an introduction by Mayching Kao.

24. For a succinct account of the Lingnan school of painting, see Chu-tsing Li's *Trends in Modern Chinese Painting,* pp. 44–50, and Ralph Croizier's *Art and Revolution in Modern China: The Lingnan (Cantonese) School of Painting (1906–1951),* which provides an interesting historical and political background for the school's artistic development.

25. Weston's photograph *Pepper* is illustrated in Barbara and John Upton's *Photography,* p. 31. (I am grateful to Eileen Seeto for pointing this out to me.)

26. See her autobiographical sketch in the Fung Ping Shan Museum's exhibition catalog *Chinese Paintings by Irene Chou* (in Chinese and English).

27. See Wucius Wong et al., *Lui Shou-kwan: 1919–1975* for illustrations of his paintings.

28. See the Fung Ping Shan Museum's catalog *Chinese Paintings by Irene Chou,* pp. 63–69, for illustrated examples of these paintings with lines.

29. She said this in her autobiographical sketch (see footnote 26) and during her conversations with me earlier this year in Hong Kong.

30. See Albright-Knox Art Gallery's exhibition catalog, *Robert Motherwell,* pp. 22–23.

IRENE CHOU

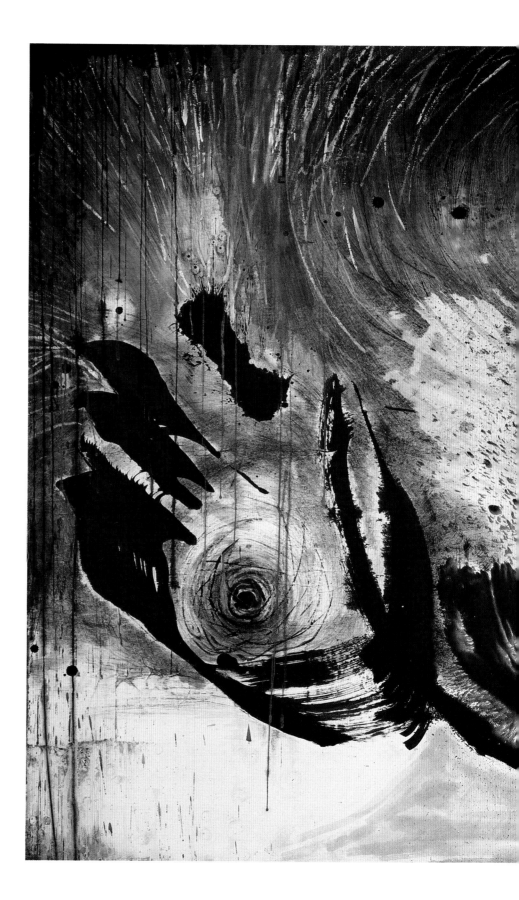

PLATE 1
Time and Space (1991)

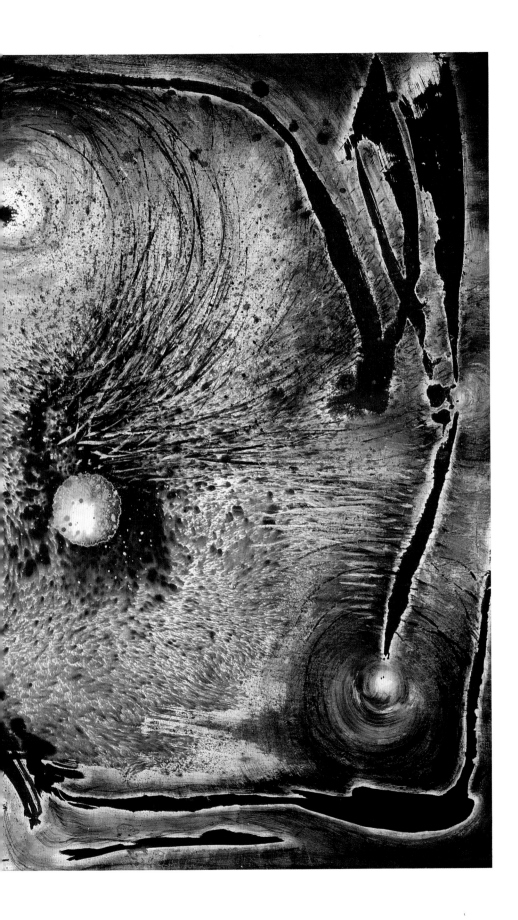

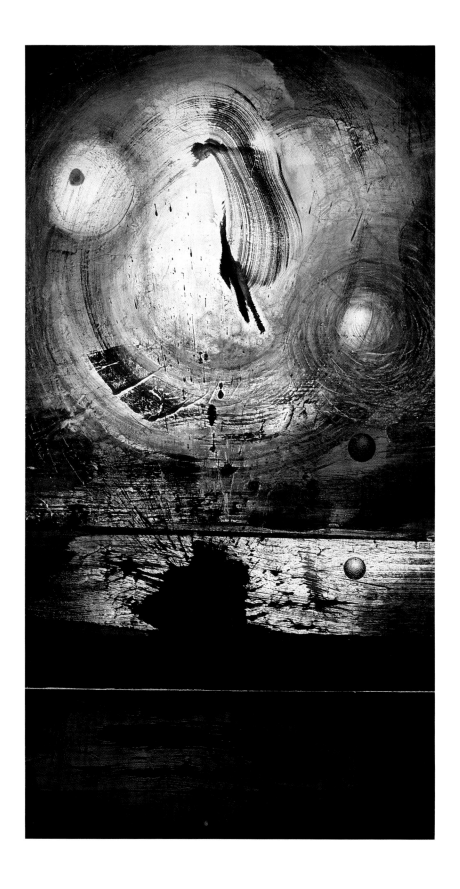

PLATE 2
Coda (1990)

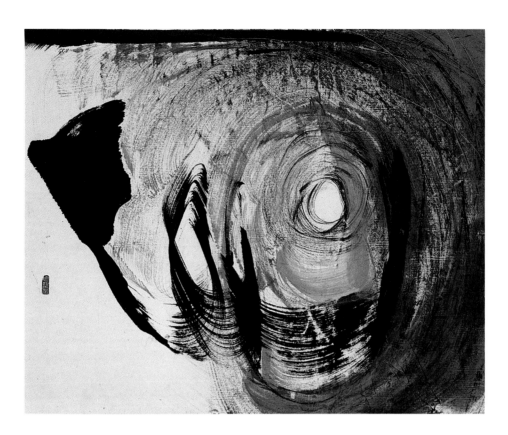

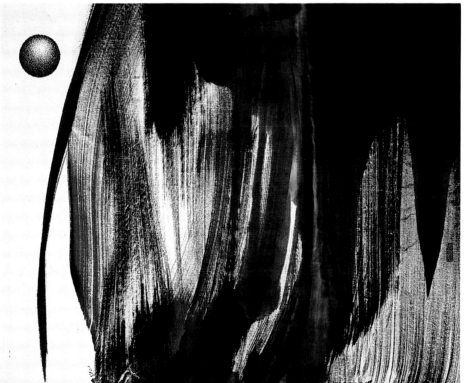

Plate 3
Abstract I (1990)

Plate 4
Abstract II (1990)

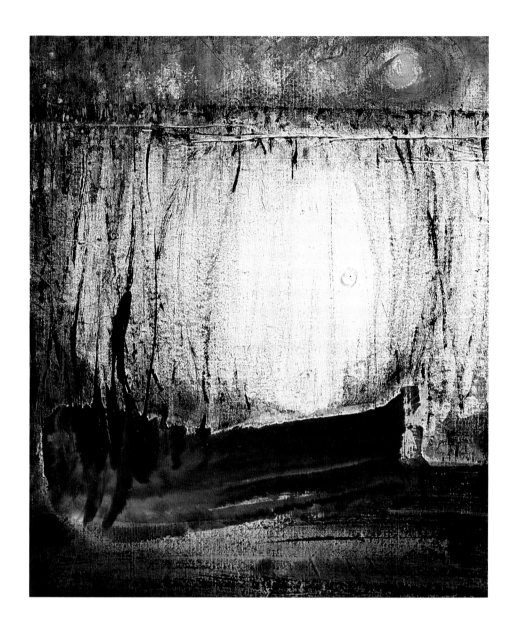

PLATE 5
Infinity I (1990)

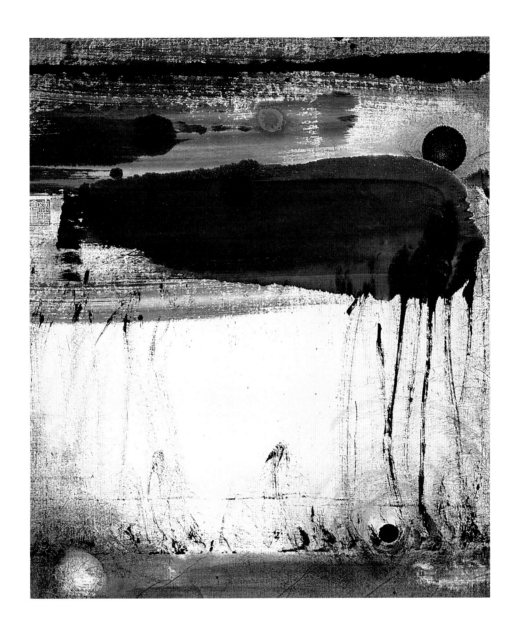

PLATE 6
Infinity II (1990)

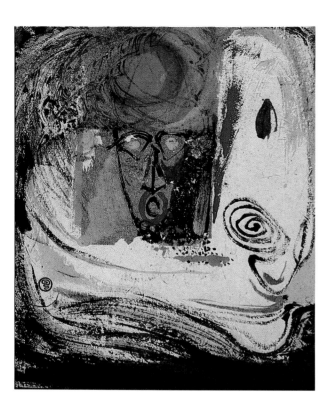

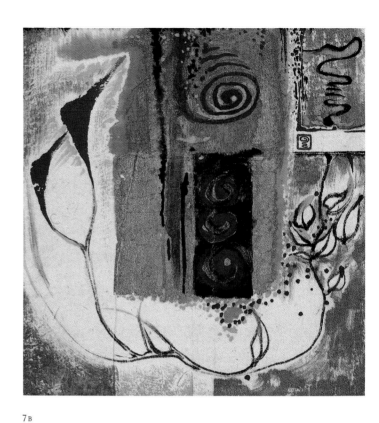

7A

7B

PLATE 7A, B
Xiaohua kaihuai (Small paintings), (1990)

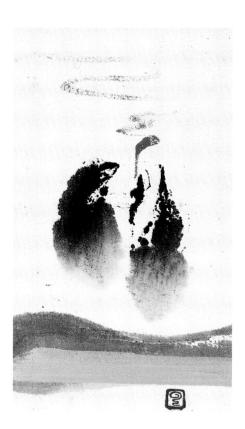

8A

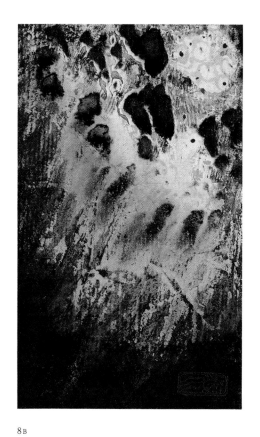

8B

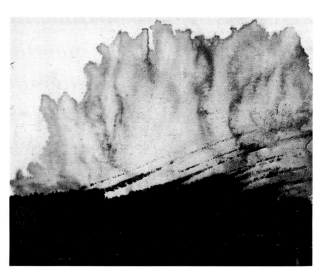

8C

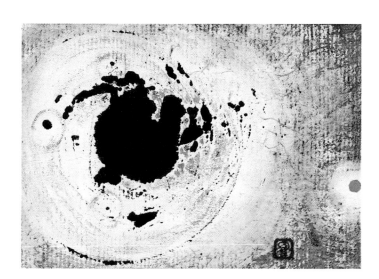

8D

PLATE 8A, B, C, D
Luyun xiaopin (Small paintings), (1990)

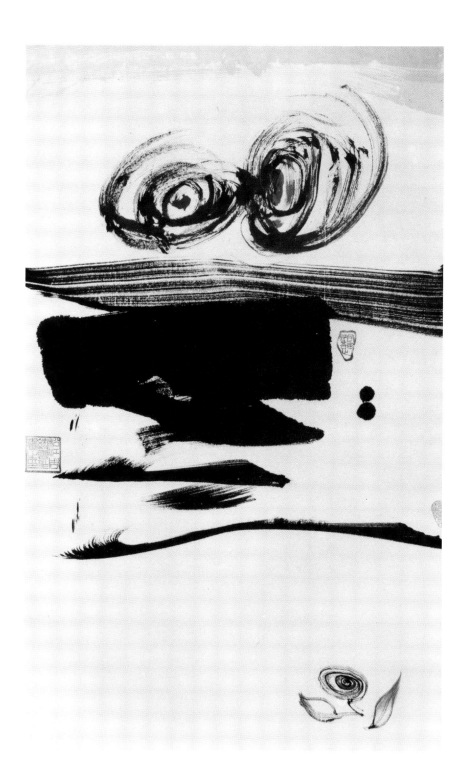

PLATE 9
Negative and Positive (1989)

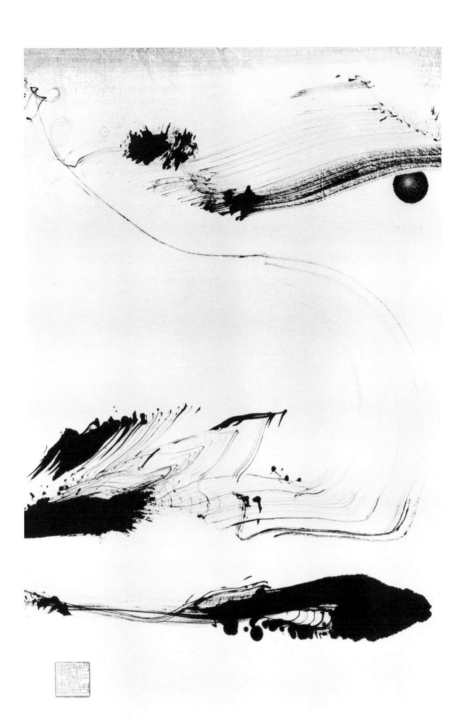

PLATE 10
Pastorale (1989)

聶鷗

NIE OU

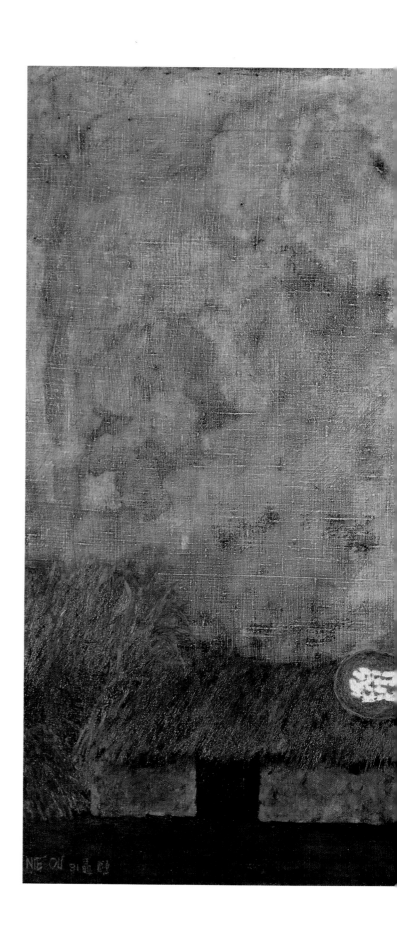

PLATE 11
A Chinese Village, dated 1991

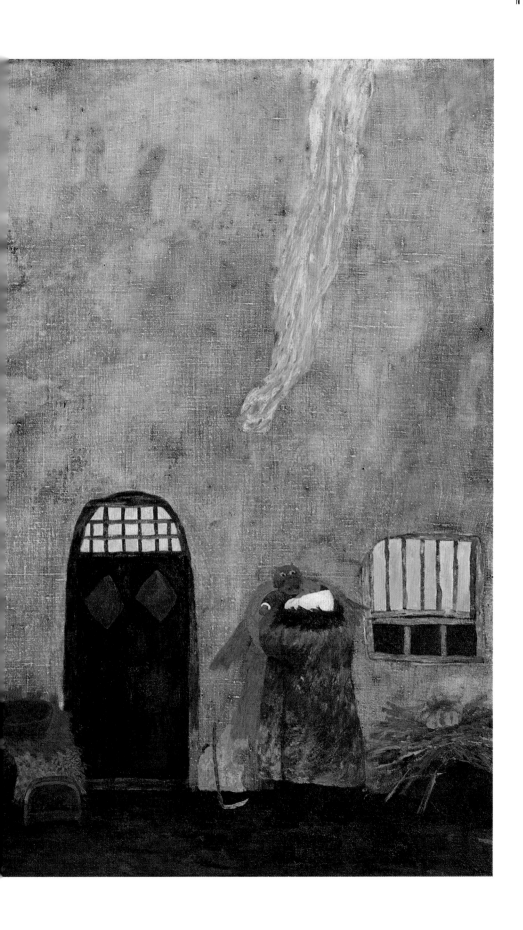

PLATE 12
A Swiss Village, dated 1991

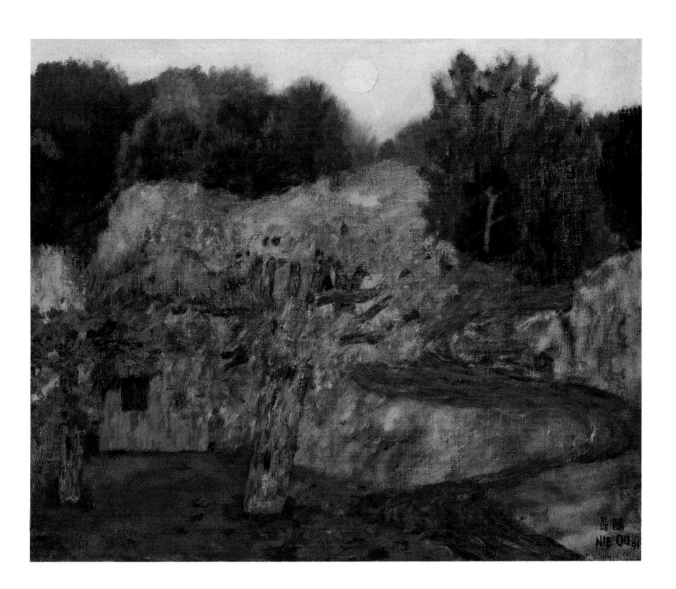

PLATE 13
Autumn Scene outside Paris, dated 1991

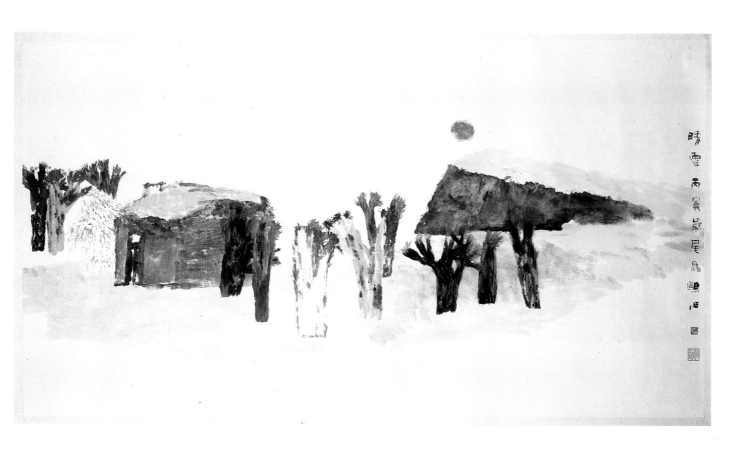

PLATE 14
After the Snow, dated *bingyin* (1986)

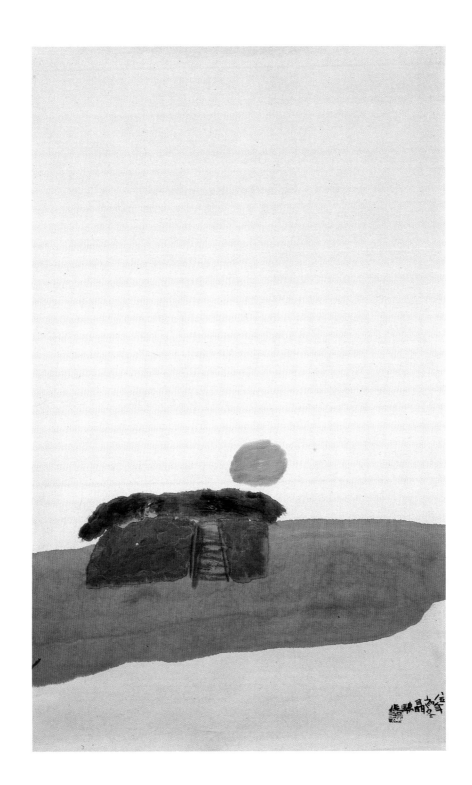

PLATE 15
Moonlit Landscape, dated winter 1985

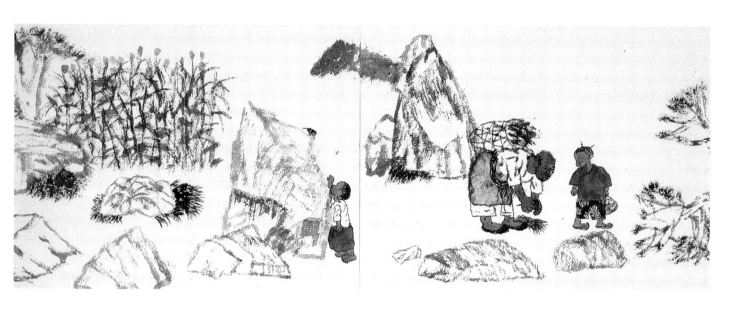

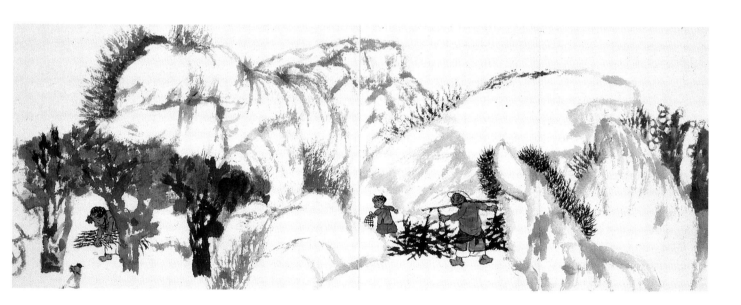

<small>PLATE 16</small>
Village Dwelling, dated *jisi* (1989)
Two double leaves from album of
fifteen double leaves

<small>PLATE 17</small>
Village Dwelling, dated spring 1990
Two double leaves from album of ten
double leaves

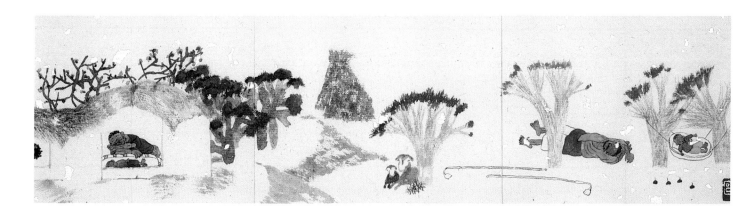

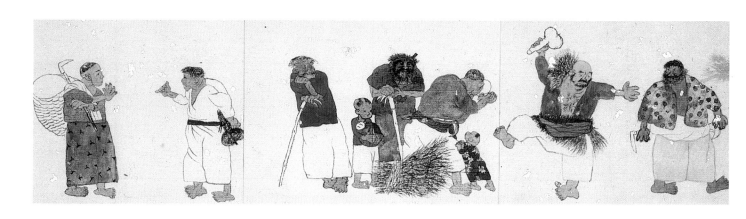

PLATE 18
Napping, dated *xinwei* (1991)
Three double leaves from album of twelve
double leaves

PLATE 19
Drinking, dated *gengwu* (1990)
Three double leaves from album of twelve
double leaves

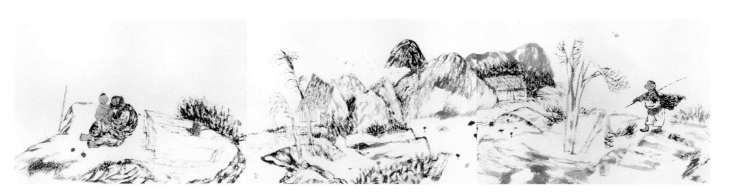

PLATE 20
Mountain Villagers, dated *jisi* (1989)
Album of 15 double leaves

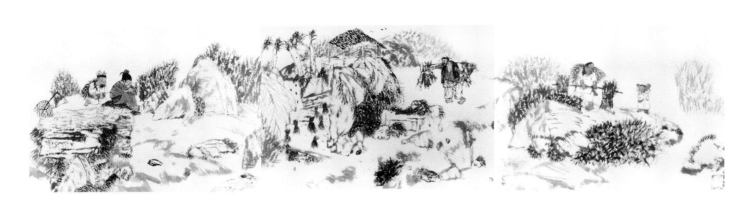

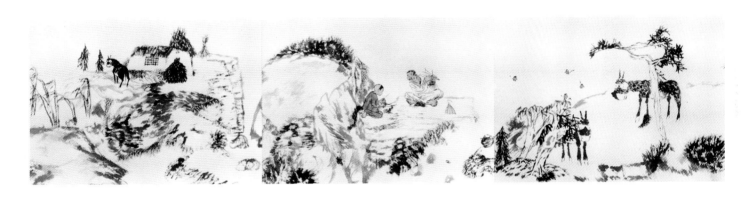

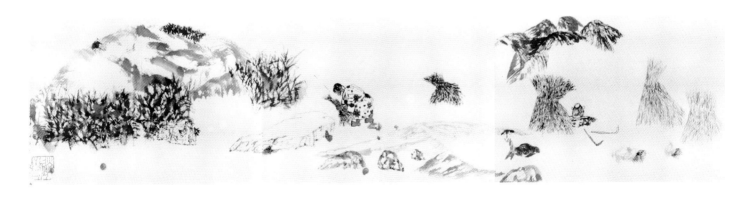

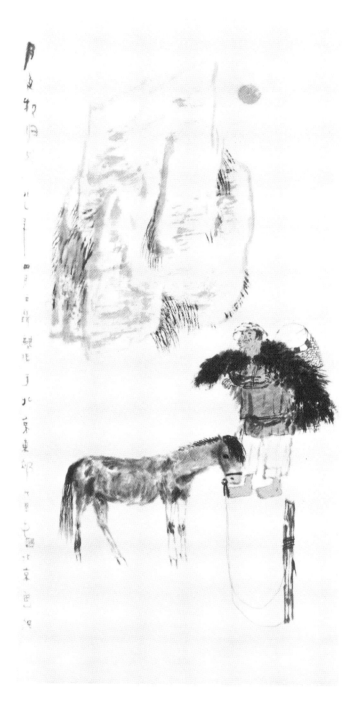

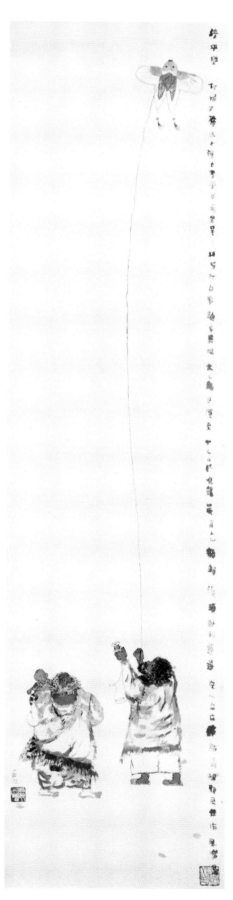

PLATE 21
Returning in the Moonlight, dated
April 1987

PLATE 22
Flying Kite, dated *gengwu* (1990)

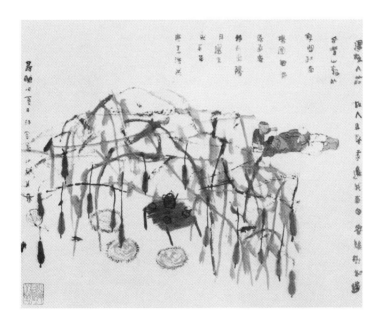

PLATE 23
Fisherman and Donkey, dated summer 1987

PLATE 24
Waiting for the Guest (1990)

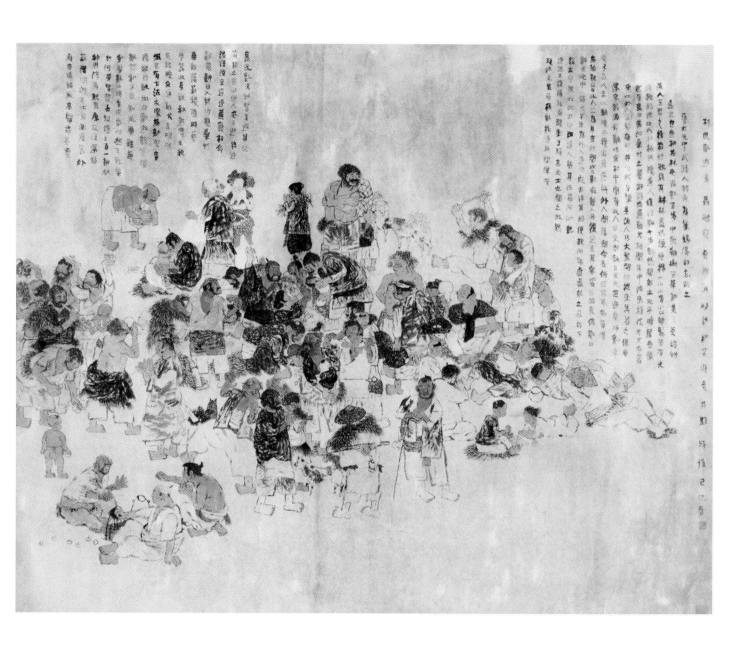

PLATE 25
Revels of the Villagers, dated *jisi* (1989)

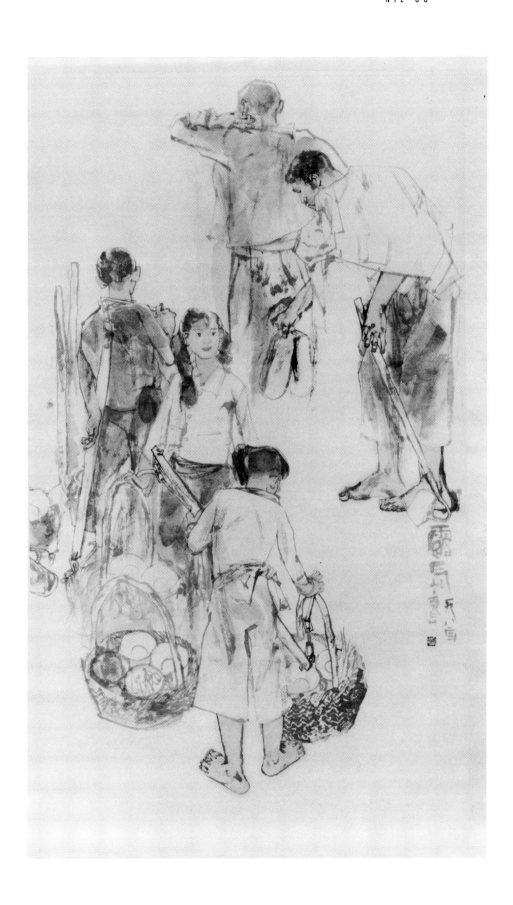

Plate 26
Dew, dated summer 1982

朱　慧　珠

NANCY CHU WOO

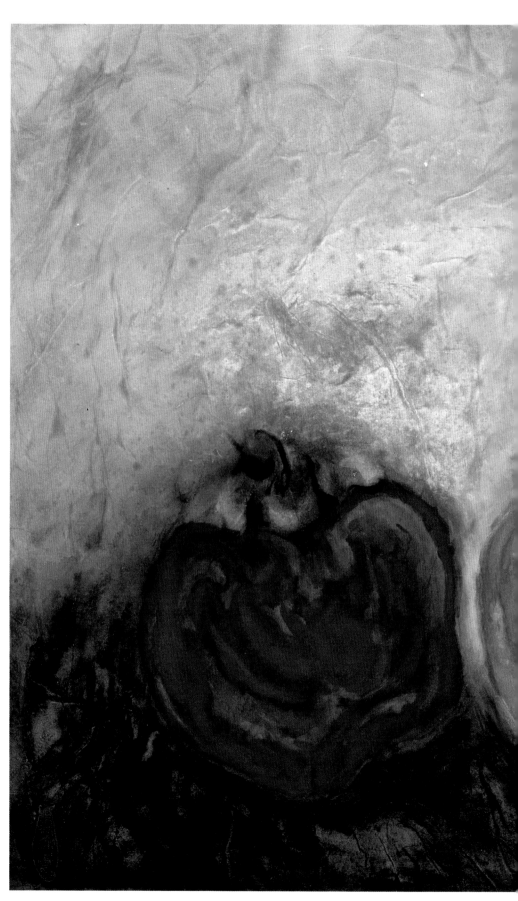

PLATE 27
Mangosteens (1991)

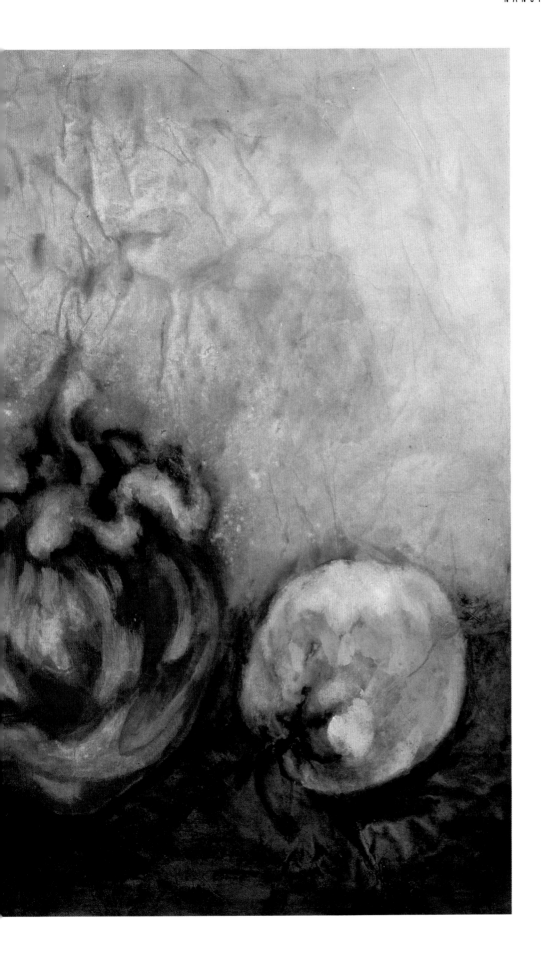

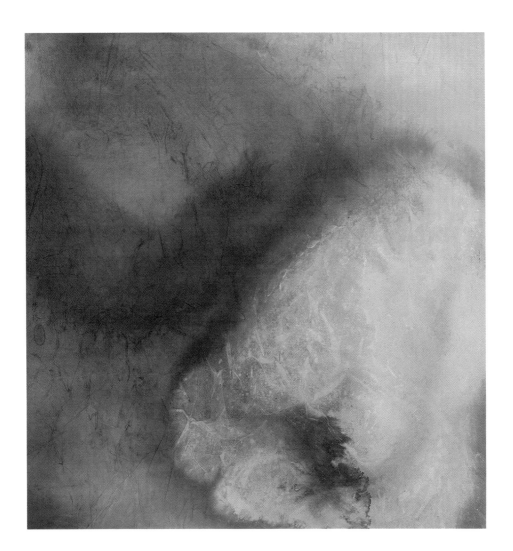

PLATE 28
Two Peppers (1990)

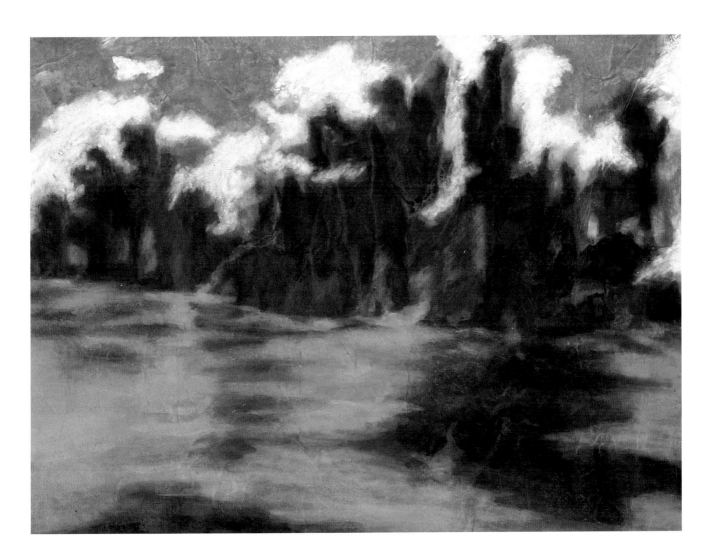

PLATE 29
Blue Cliffs (1990)

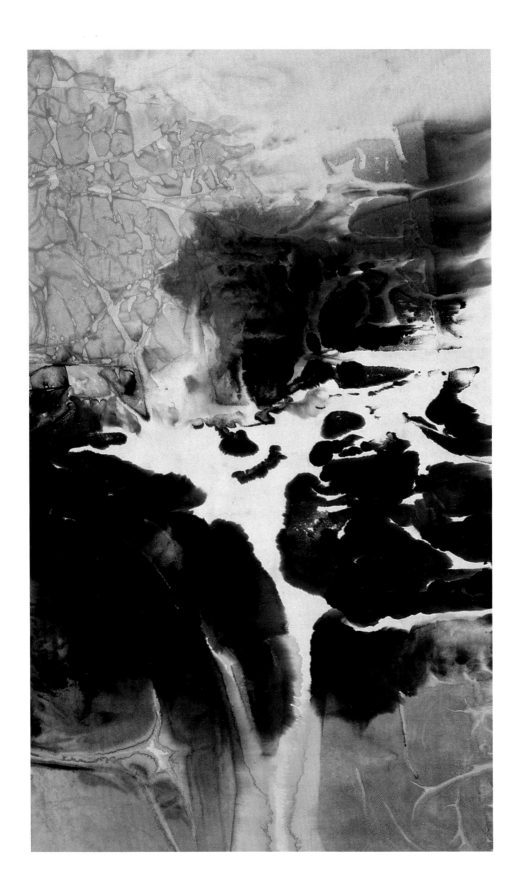

PLATE 30
Waterfall (1989)

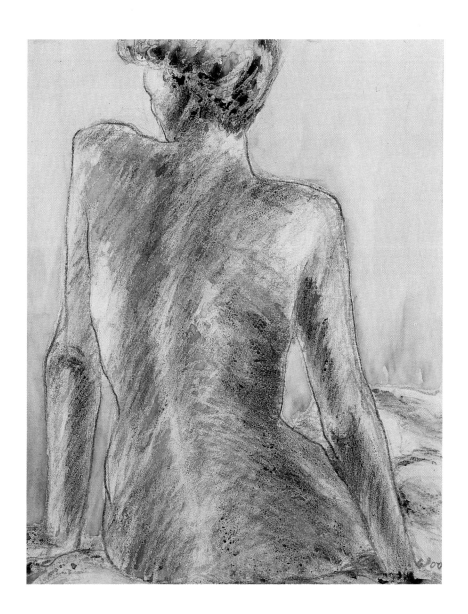

PLATE 31
Seated Nude (1982)

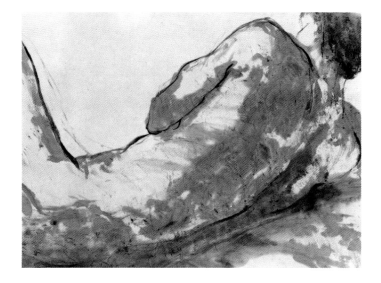

PLATE 32
Reclining Male Nude (1982)

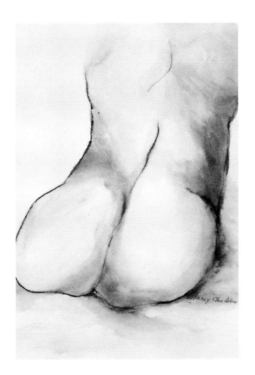

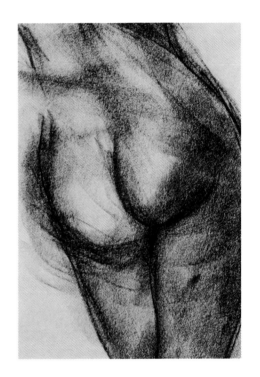

PLATE 33
Female Torso (1988)

PLATE 34
Female Torso (1982)

YANG YANPING

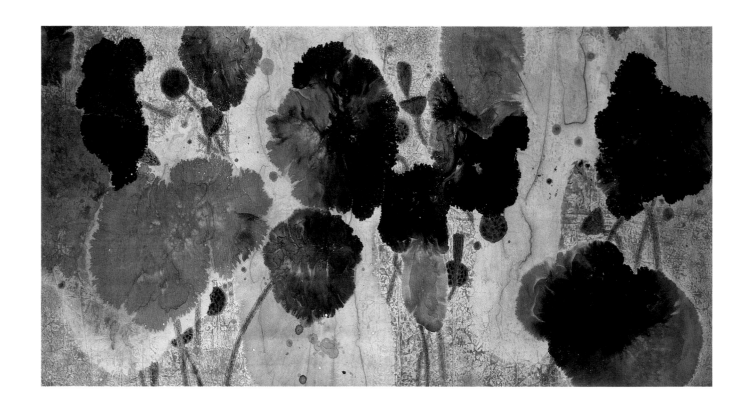

PLATE 35
Winter Lotus Pond (1988)

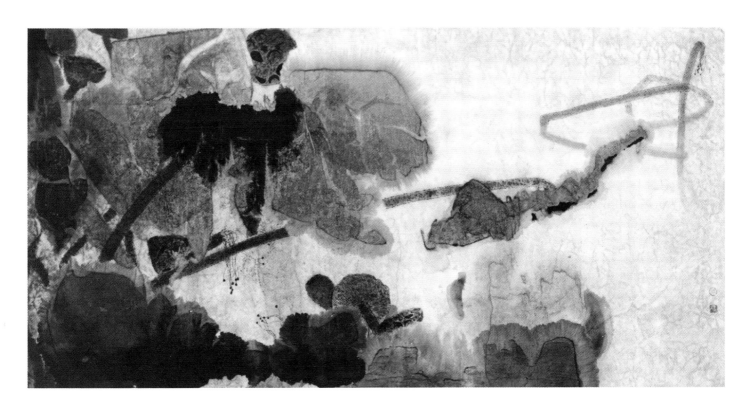

PLATE 36
Lotus (1991)

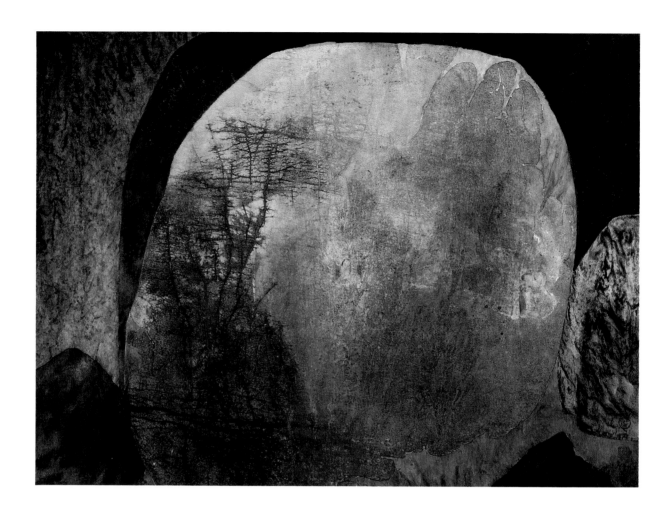

PLATE 37
Rocks (1989)

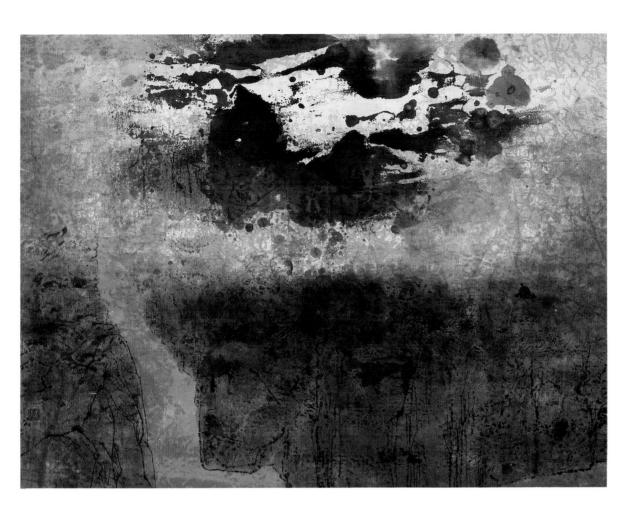

PLATE 38
Gorge under Dense Fog (1987)

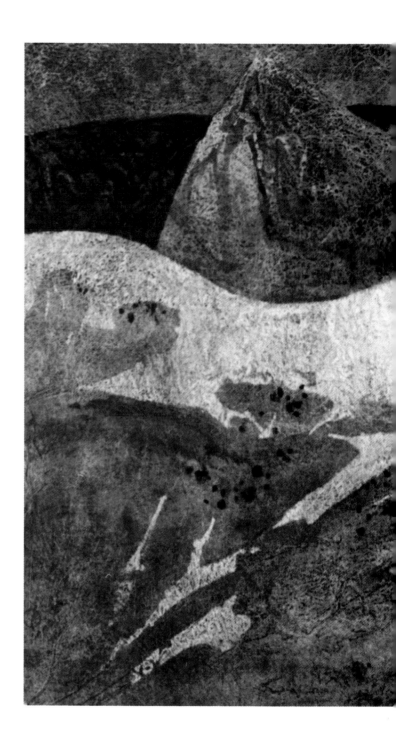

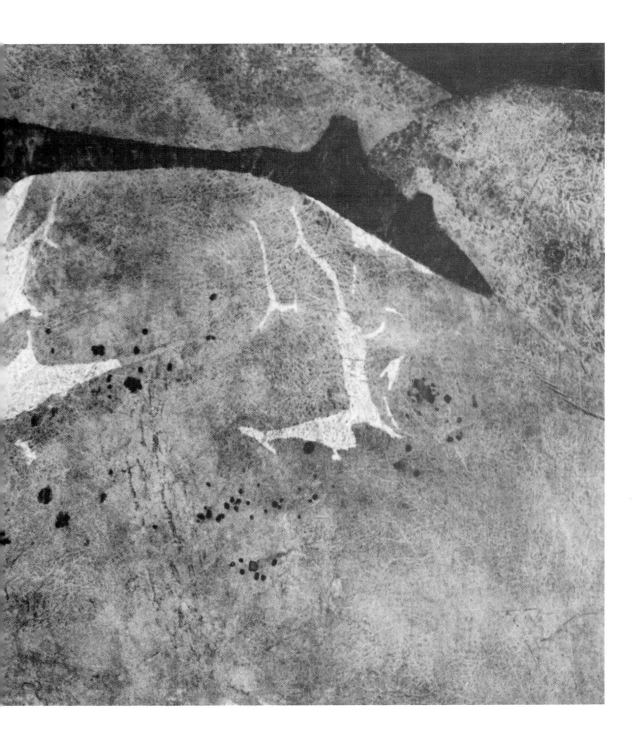

Mountains (1988)

赵秀焕

ZHAO XIUHUAN

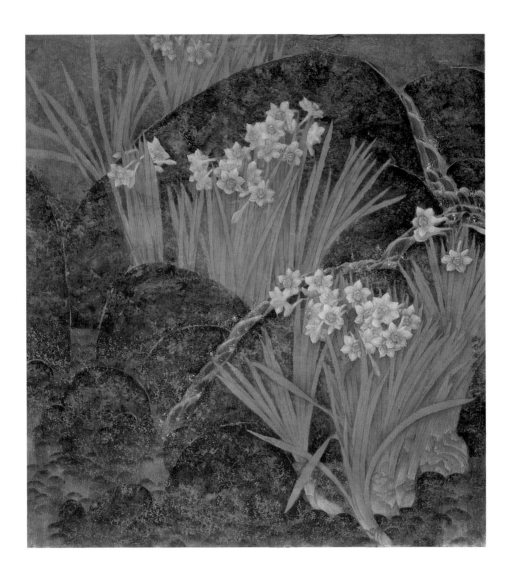

PLATE 40
New Spring, dated *gengwu* (1990)

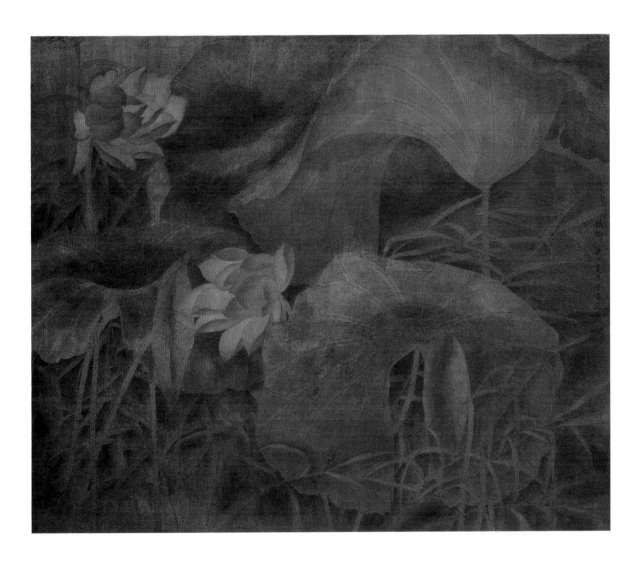

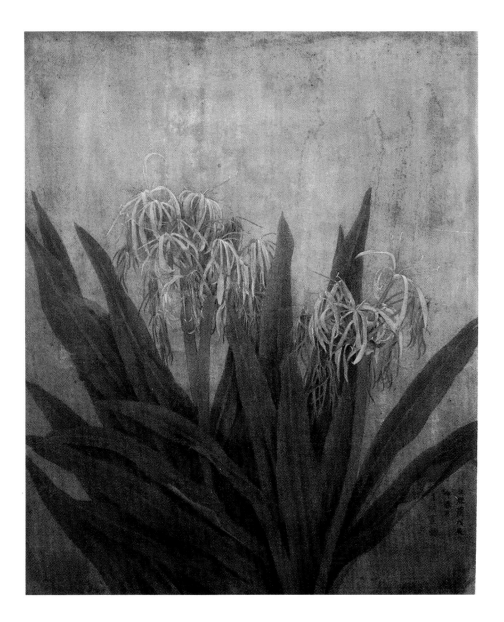

PLATE 42
Spider Lilies, dated spring of *wuchen* (1988)

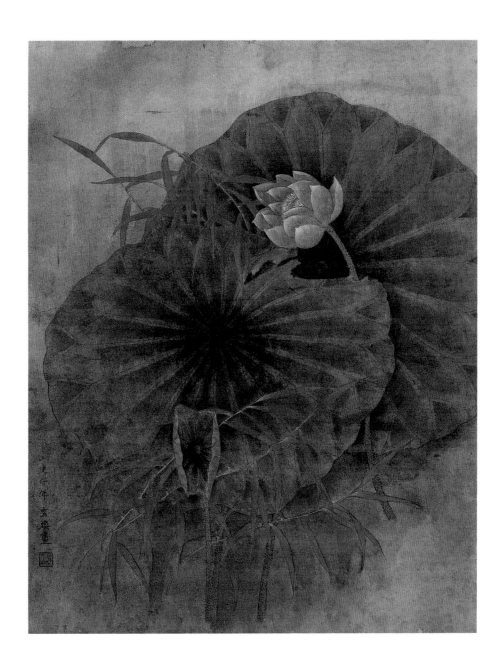

PLATE 43
Lotus, dated *gengwu* (1990)

70

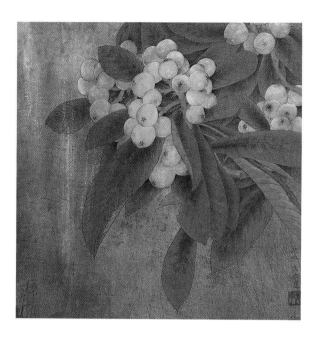

PLATE 44
Loquats, dated *gengwu* (1990)

PLATE 45
Peony (1990)

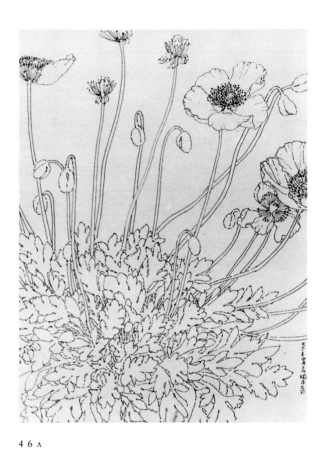

4 6 A

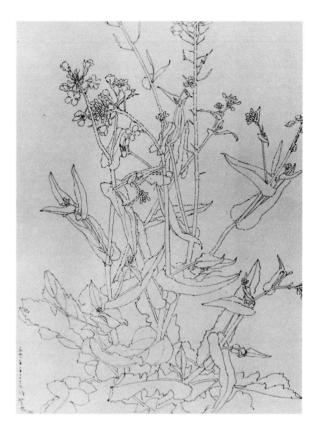

4 6 B

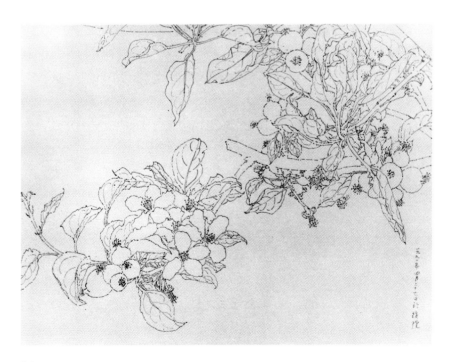

4 6 C

<small>PLATE 46A,B,C</small>

Three flower sketches dated 1991 from her
sketchbook

周思聰

ZHOU SICONG

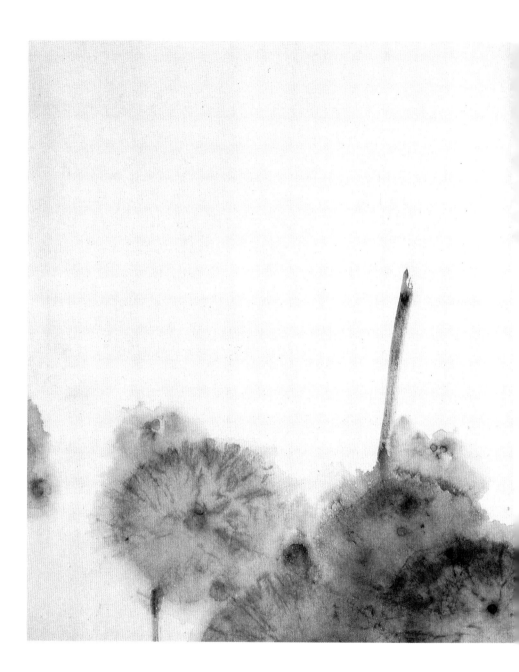

PLATE 47
Lotus, dated *gengwu* (1990)

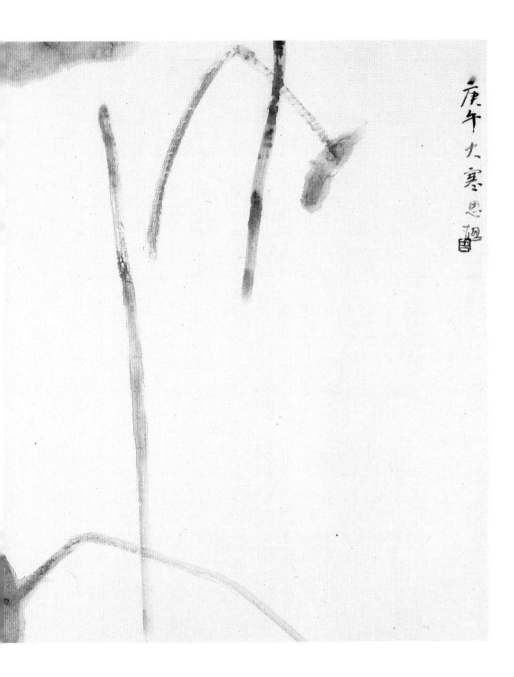

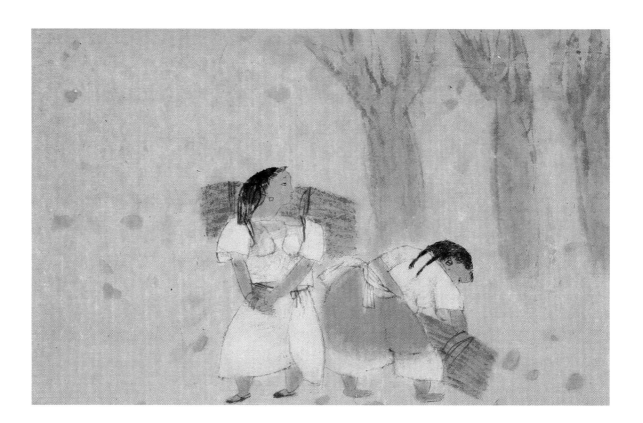

PLATE 48
Two Women Gathering Firewood (1989)

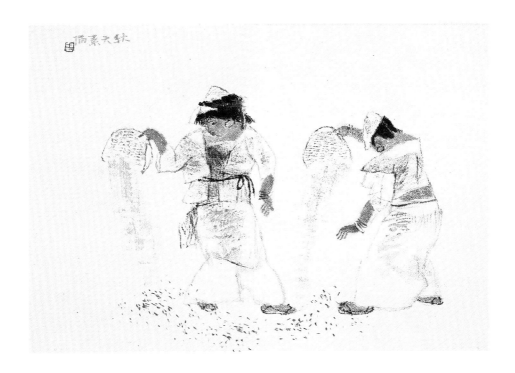

PLATE 49A & B
Village Scene and *Two Women
Sifting Grains*
Two paintings from album of twenty
paintings dated *wuchen* (1988)

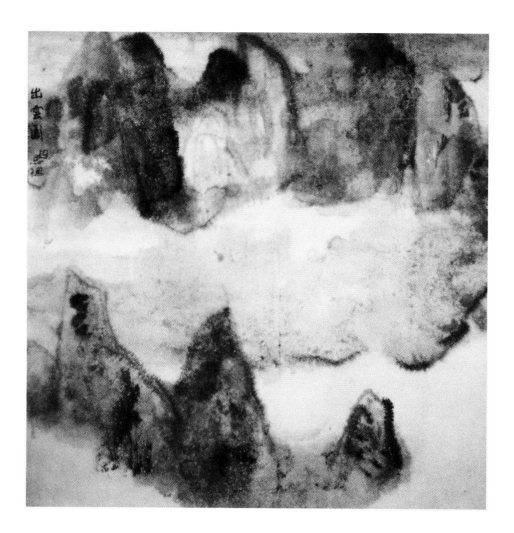

PLATE 50
Clouds (1985)

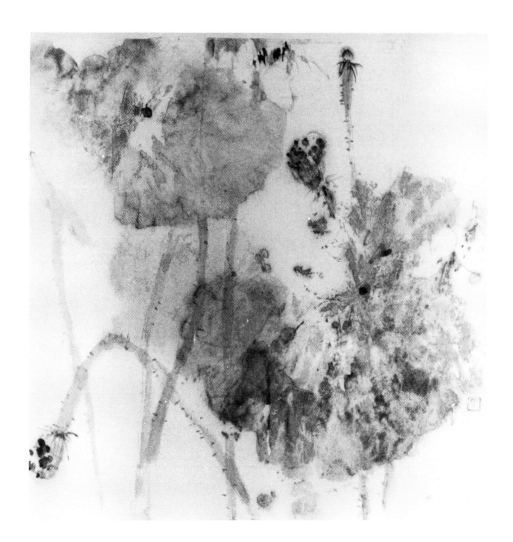

PLATE 51
Lotus (1985)

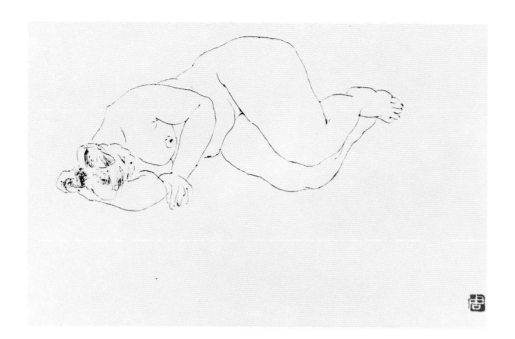

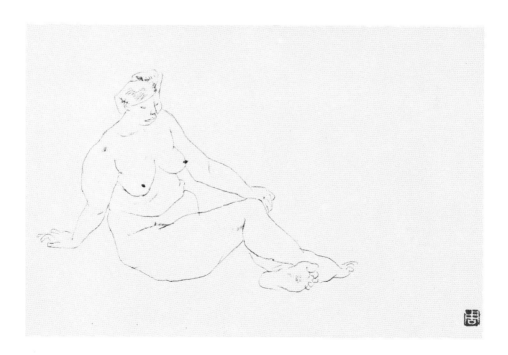

PLATE 52
Nude (1985)

PLATE 53
Nude (1985)

PLATES 54–57
Set of four figure sketches depicting the Yi
minority people of Sichuan Province

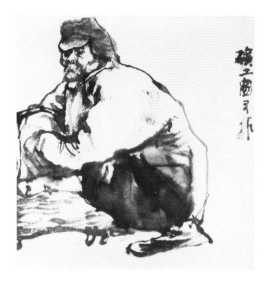

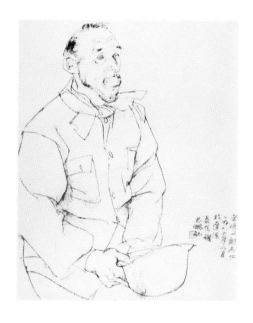

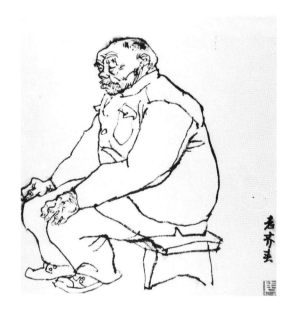

PLATE 58
Miner (1980)

PLATE 59
Miner, dated April 1980

PLATE 60
An Old Man (1980)

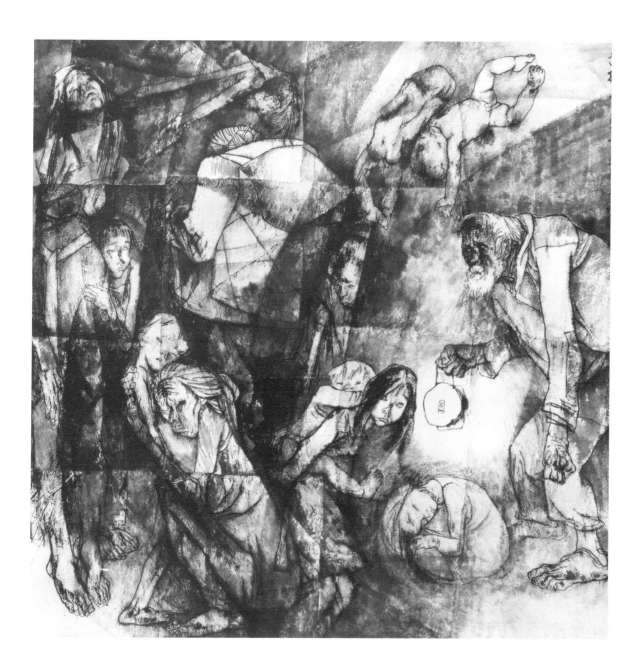

PLATE 61
The Abandoned, dated January, 1981

**Irene Chou
(Zhou Luyun)**

PLATE 1

Time and Space (1991). Signed Luyun. One Seal: Zhou Luyun
Chinese ink and color on paper, $60\frac{1}{4}$ x $83\frac{7}{8}$ inches (153 x 213 cm),
mounted and framed

PLATE 2

Coda (1990). One seal: Luyun huihua
Chinese ink and color on paper, $69\frac{1}{4}$ x 38 inches (176 x 96.5 cm), hanging scroll

PLATE 3

Abstract I (1990). One seal: Zhou Luyun hua
Chinese ink and color on paper, 19 x 24 inches (48 x 61 cm), mounted and framed

PLATE 4

Abstract II (1990). One seal: Zhou Luyun hua
Chinese ink and color on paper, 19 x 24 inches (48 x 61 cm), mounted and framed

PLATE 5

Infinity I (1990). One seal: Zhou Luyun yin
Chinese ink and color on paper, 21 x $18\frac{1}{2}$ inches (53 x 47 cm), hanging scroll

PLATE 6

Infinity II (1990). One seal: Zhou Luyun yin
Chinese ink and color on paper, 21 x $18\frac{1}{2}$ inches (53 x 47 cm), hanging scroll

PLATE 7A, B

Xiaohua kaihuai (Small paintings), (1990). Title inscribed by artist on title slip
Album I: eight leaves, all stamped with one seal. Signed Luyun. One seal: zi de qi le
Chinese ink and color on paper, some with metallic (gold or silver) foil
Two leaves illustrated: 5 x 5 inches (13 x 13 cm); $5\frac{5}{8}$ x $4\frac{7}{8}$ inches (14.5 x 12.5 cm)

PLATE 8A, B, C, D

Luyun xiaopin (Small paintings), (1990). Title inscribed by artist on title slip
Album II: 10 leaves, all stamped with one seal
Chinese ink and color on paper, some with metallic (gold or silver) foil
Four leaves illustrated: 4 x $2\frac{3}{8}$ inches (10 x 6 cm); $3\frac{3}{4}$ x $2\frac{1}{4}$ inches (9.5 x 6 cm);
$2\frac{5}{8}$ x $3\frac{1}{4}$ inches (6.5 x 8 cm); $2\frac{1}{2}$ x $3\frac{5}{8}$ inches (6.5 x 9 cm)

PLATE 9

Negative and Positive (1989). Three seals: Songjiang Zhou Luyun zuohua zhiyin,
yuzhou ji wuxin, and zuoge kuaile laoshiren
Chinese ink and color on paper, 38 x $22\frac{1}{2}$ inches (96.5 x 57 cm), hanging scroll

PLATE 10

Pastorale (1989). One seal: Songjiang Zhou Luyun zuohua zhiyin
Chinese ink and color on paper, 38 x 23 inches (96.5 x 58.5 cm), hanging scroll

NOTE: Height precedes width for measurements of paintings, exclusive
of mounting. Dates in parentheses are given by the artists, unless it is
specifically stated the painting is dated.

Nie Ou

PLATE 11
A Chinese Village, dated 1991. Signed Nie Ou in both English and Chinese
Oil on linen, 19⅝ x 24 inches (50 x 61 cm), framed

PLATE 12
A Swiss Village, dated 1991. Signed Nie Ou in both English and Chinese
Oil on canvas, 19⅝ x 24 inches (50 x 61 cm), framed

PLATE 13
Autumn Scene outside Paris, dated 1991. Signed Nie Ou in both English and Chinese
Oil on canvas, 13 x 16 inches (33 x 41 cm), not in exhibition (illustration only)

PLATE 14
After the Snow, dated *bingyin* (1986). Title inscribed by artist. Signed Nie Ou
Two seals: Nie Ou and *songdao*
Chinese ink and color on paper, 38½ inches x 71 inches (98 x 180 cm),
mounted and framed

PLATE 15
Moonlit Landscape, dated winter 1985. Signed Nie Ou. One Seal: Nie Ou
Chinese ink and color on paper, 38 x 23½ inches (96.5 x 60 cm), mounted and framed

PLATE 16
Village Dwelling, dated *jisi* (1989). Album of 15 double leaves
Title inscribed by artist on title slip with artist's signature and one seal: Nie Ou
Signed Nie Ou with one seal: Nie Ou on leaf 1a. Signed Nie Ou, dated winter of
jisi (1989), with two seals: Nie Ou and *songdao* on leaf 15b
Chinese ink and color on paper, each leaf measures 6¼ x 4¼ inches (16 x 11 cm)

PLATE 17
Village Dwelling, dated spring 1990. Album of 10 double leaves
Title inscribed by artist on title slip with one seal: Nie Ou. Signed Nie Ou,
dated spring 1990, with one seal: Nie Ou on leaf 10b
Chinese ink and color on paper, each leaf measures 6¼ x 4¼ inches (16 x 11 cm)

PLATE 18
Napping, dated *xinwei* (1991). Album of 12 double leaves
Title inscribed by artist on title slip with artist's signature and one seal: Nie Ou
Signed Nie Ou with one seal: Nie Ou on leaf 1a. Signed Nie Ou, dated spring of
xinwei (1991), with two seals: Nie Ou and *songdao* on leaf 12b
Chinese ink and color on gold-flecked paper, each leaf measures 4½ x 2¾ inches
(11.5 x 7 cm)

PLATE 19
Drinking, dated *gengwu* (1990). Album of 12 double leaves
Title inscribed by artist on title slip with artist's signature and one seal: Nie Ou
Signed Nie Ou, dated *gengwu* (1990), with one seal: Nie Ou on leaf 12a;
one seal *songdao* on leaf 12b
Chinese ink and color on gold-flecked paper, each leaf measures 4½ x 2¾ inches
(11.5 x 7 cm)

**Nie Ou
cont.**

PLATE 20

Mountain Villagers, dated *jisi* (1989). Album of 15 double leaves. Title inscribed by artist on title slip with artist's signature and one seal: Nie Ou. Signed Nie Ou, dated autumn of *jisi* (1989), with two seals: Nie Ou and *songdao* on leaf 15f
Chinese ink and color on paper, each leaf measures 8¾ x 6½ inches (22.5 x 16.5 cm)

PLATE 21

Returning in the Moonlight, dated April 1987. Title inscribed by artist with artist's signature and one seal: Nie Ou
Chinese ink and color on paper, 54 x 26 inches (137 x 67 cm), hanging scroll

PLATE 22

Flying Kite, dated *gengwu* (1990). Title and poem inscribed by artist with artist's signature and two seals: Nie Ou and *songdao*
Chinese ink and color on paper, 53¾ x 13½ inches (136.5 x 34 cm), hanging scroll

PLATE 23

Fisherman and Donkey, dated summer 1987. Signed Nie Ou. One seal: Nie Ou
Chinese ink and color on paper, 27 x 27 inches (68 x 68 cm), mounted and framed

PLATE 24

Waiting for the Guest (1990). Title and poem by Tang poet Meng Haoran inscribed by artist with artist's signature and two seals: Nie Ou and *songdao*
Chinese ink and color on paper, 16½ x 20⅜ inches (42 x 52 cm), mounted and framed

PLATE 25

Revels of the Villagers, dated *jisi* (1989). Title and poem inscribed by artist. The inscriptions indicate the painting is based on Tao Yuanming's poem *The Peach Blossoms Garden* of the Jin dynasty (265–420). Signed Nie Ou and dated *jisi* (1989) with two seals
Chinese ink and color on paper, 78¾ x 78¾ inches (200 x 200 cm), not in exhibition (illustration only)

PLATE 26

Dew, dated summer 1982. Title inscribed by artist. Signed Nie Ou. One seal: Nie Ou
Chinese ink and color on paper, 64¾ x 37½ inches (164.5 x 95 cm), not in exhibition (illustration only)

Nancy Chu Woo
PLATE 27
Mangosteens (1991). Signed Chuzhu. One seal: Zhu Chuzhu hua
Ink and gouache on paper, 25½ x 33½ inches (65 x 85 cm), mounted and framed

PLATE 28
Two Peppers (1990). Signed Chuzhu. One seal: Zhu Chuzhu
Gouache on paper, 26½ x 26 inches (67.5 x 66 cm), hanging scroll

PLATE 29
Blue Cliffs (1990). Signed Zhu. One seal: Zhu Chuzhu yin
Ink and gouache on paper, 24 x 32¼ inches (61 x 82 cm), mounted and framed

PLATE 30
Waterfall (1989). Signed Chuzhu. One seal: Zhu Chuzhu yin
Ink and gouache on paper, 50 x 29½ inches (127 x 75 cm), hanging scroll

PLATE 31
Seated Nude (1982). Signed Woo
Pastel and watercolor on paper, 25¼ x 19½ inches (64 x 49.5 cm), mounted and framed

PLATE 32
Reclining Male Nude (1982). Signed Woo
Charcoal on paper, 19½ x 26¾ inches (49.5 x 68 cm), mounted and framed

PLATE 33
Female Torso (1988). Signed Nancy Chu Woo
Watercolor on paper, 27 x 20 inches (68 x 50 cm), mounted and framed

PLATE 34
Female Torso (1982). Signed Woo
Charcoal on paper, 15 x 10¼ inches (38 x 26.5 cm), mounted and framed

Yang Yanping

PLATE 35
Winter Lotus Pond (1988). Two seals: Yang and Yan
Chinese ink and color on paper, 47 x 83 inches (119.5 x 211 cm), mounted and framed

PLATE 36
Lotus (1991). Two seals: Yang and Yan
Chinese ink and color on paper, 26 x 52 inches (66 x 132 cm), not in exhibition
(illustration only)

PLATE 37
Rocks (1989). Two seals: Yang and Yan
Chinese ink and color on paper, 24 x 32¼ inches (61 x 82 cm), mounted and framed

PLATE 38
Gorge under Dense Fog (1987). Two seals: Yang and Yan
Chinese ink and color on paper, 23 x 30⅝ inches (58.5 x 78 cm), mounted and framed

PLATE 39
Mountains (1988). Two seals: Yang and Yan
Chinese ink and color on paper, 24 x 36 inches (61 x 91.5 cm), mounted and framed

Zhao Xiuhuan

PLATE 40
New Spring, dated *gengwu* (1990). Title inscribed by artist. Signed Zhao Xiuhuan
One seal: Zhao Xiuhuan
Chinese ink and color on paper, 28¼ x 26 inches (69 x 66 cm), mounted and framed

PLATE 41
Green Lotuses, dated summer of *gengwu* (1990). Title inscribed by artist. Signed Xiuhuan
One seal: Zhao Xiuhuan yin
Chinese ink and color on paper, 28½ x 35 inches (72.5 x 89 cm), mounted and framed

PLATE 42
Spider Lilies, dated spring of *wuchen* (1988). Title *wenshu lan* inscribed by artist
Signed Xiuhuan. Two seals: Zhao and Xiuhuan
Chinese ink and color on paper, 27½ x 22½ inches (70 x 57 cm), mounted and framed

PLATE 43
Lotus, dated *gengwu* (1990). Signed Xiuhuan. One seal: Zhao Xiuhuan
Chinese ink and color on paper, 27½ x 21½ inches (70 x 54.5 cm), mounted and framed

PLATE 44
Loquats, dated *gengwu* (1990). Signed Xiuhuan. One seal: Xiuhuan
Chinese ink and color on paper, 13¾ x 13¾ inches (35 x 35 cm), album leaf
(from album of six leaves)

PLATE 45
Peony (1990). Signed Xiuhuan hua. One seal: Zhao
Chinese ink and color on paper, 15 x 16 inches (38 x 41 cm), mounted and framed

PLATE 46A, B, C
Sketchbook of flower studies done in California, dated December 25, 1989, on title page
Mostly signed Xiuhuan, and dated 1990 and 1991
Pen and ink on paper, 13⅝ x 10¾ inches (34.5 x 27 cm)

Zhou Sicong

PLATE 47
Lotus, dated *gengwu* (1990). Signed Sicong. One seal: Zhou
Chinese ink and color on paper, 21½ x 39½ inches (54 x 100 cm),
mounted and framed

PLATE 48
Two Women Gathering Firewood (1989). One seal: Zhou
Chinese ink and color on paper, 16½ x 26¾ inches (42 x 68 cm),
mounted and framed

PLATE 49A & B
Shepi chengqu (Painting for pleasure), dated *wuchen* (1988)
Album of 10 double leaves with paintings on both front and back (20 paintings total)
Title inscribed by artist, signed Sicong with one seal: Zhou, and dated *wuchen* (1988)
on front cover
Chinese ink and color on paper, each leaf measures 16 x 11¾ inches
(40.5 x 30 cm). Two leaves illustrated: *Village Scene* and *Two Women Sifting Grains*

PLATE 50
Clouds (1985). Title inscribed by artist. Signed Sicong. One seal: Zhou
Chinese ink on paper, 26¾ x 26¾ inches (68 x 68 cm), mounted and framed

PLATE 51
Lotus (1985). One seal: Si
Chinese ink on paper, 27⅛ x 27⅛ inches (69 x 69 cm), mounted and framed

PLATE 52
Nude (1985). One seal: Zhou
Pen and ink on paper, not in exhibition (illustration only)

PLATE 53
Nude (1985). One seal: Zhou
Pen and ink on paper, not in exhibition (illustration only)

PLATES 54–57
Set of four figure sketches depicting the Yi minority people of Sichuan Province (1981)
Each sketch is stamped with one seal: Zhou
Charcoal on paper, each sketch measures 12 x 11 inches (30.5 x 28 cm),
mounted and framed

PLATE 58
Miner (1980). One seal: Zhou
Charcoal on paper, 13½ x 13½ inches (34 x 34 cm), not in exhibition (illustration only)

PLATE 59
Miner, dated April 1980. Signed Sicong. One seal: Zhou
Pen and ink on paper, 19¾ x 14½ inches (50 x 37 cm), not in exhibition
(illustration only)

PLATE 60
An Old Man (1980). One seal: Zhou
Chinese ink on paper, 13½ x 13½ inches (34 x 34 cm), not in exhibition
(illustration only)

PLATE 61
Miners Painting Series No. 6. *The Abandoned,* dated January 1981
Signed Zhou Sicong and Lu Chen. Two seals
Chinese ink and color on paper, not in exhibition (illustration only)

**Irene Chou
(Zhou Luyun)**

周綠雲

1924	Born in Shanghai, China
1945	Graduated with B.A. degree in economics from St. John's University in Shanghai
1949	Worked as a reporter for the *Peace Daily* in Shanghai
	Moved to Hong Kong; married
1950	Began to study traditional Chinese painting methods under Zhao Shaoang and Lu Shoukun
1976–84	Art instructor at University of Hong Kong Extramural Department

Awards:

1972	Pacific Asia Museum Fine Art Award, Pasadena, CA
1983	The Urban Council Fine Art Award, Hong Kong
1988	Artist of the Year Award, Hong Kong

Selected Group Exhibitions:

1968–70	"201st & 202nd Royal Academy of Arts Exhibition," London
1977	"Inaugural Exhibition," Hong Kong Arts Centre
1977–86	Annual "First Choice," Hong Kong
1986	"Hong Kong Art 76–86," Fung Ping Shan Museum, University of Hong Kong
1987	"Ten Years of Hong Kong Paintings," Hong Kong Arts Centre
1988	"Modern Art Hong Kong," Beijing
	"Icons of the Imagination," Hanart 2 Gallery, Hong Kong
1989	"Modern Art Hong Kong," Japan
1991	"Art Works of Hong Kong Women Artists '91," Hong Kong Institute for the Promotion of Chinese Culture

Selected Solo Exhibitions:

1970	City Hall, Hong Kong
1971	The American Library, Hong Kong, presented by the United States Cultural Center
1977	Raya Gallery, Melbourne, Australia
1983	City Gallery, Manila, the Philippines
1986	Fung Ping Shan Museum, University of Hong Kong
1987	Museo Luis de Cameos, Macau
1988	Hanart Gallery, New York
1989	Galerie Art East/Art West, Hamburg, West Germany
	Hanart 2 Gallery, Hong Kong
1991	"Recent Paintings—Irene Chou," Hanart T Z Gallery, Hong Kong
	"Irene Chou," Ginza Art Museum, Tokyo
	"Irene Chou," Gerald Godfrey Far Eastern Art, London

Collections:

Hong Kong Museum of Art
Fung Ping Shan Museum, University of Hong Kong
National Museum of History, Taipei, Taiwan
National Arts Center, Taipei, Taiwan
National Museum of Singapore
City Gallery, Manila, the Philippines
Raya Gallery, Melbourne, Australia
Galerie Art East/Art West, Hamburg, West Germany

Various private collections in Australia, Canada, England, France, Hong Kong, Japan, Switzerland, the Philippines, and the United States

NOTE: The biographies are based on information provided by the artists and various publications.

Nie Ou

聂　鸥

1948	Born in Shenyang City, Liaoning Province, China
1954	Moved to Beijing with her parents
1960–66	Studied art at the Youth Palace (Municipal Children's Center) in Beijing
1969	Assigned to farm at Datong, Shanxi Province, during the Cultural Revolution
1978	Admitted into the graduate school at the Central Art Academy in Beijing, majoring in traditional Chinese painting (*guohua*); among her tutors were Li Keran, Jiang Zhaohe, Li Kuchan, Ye Qianyu; studied mainly with Lu Chen
1981	Became professional artist affiliated with the Beijing Painting Academy; married artist Sun Weimin
1985	Elected member of the Chinese Artists' Association

Awards:

1981	Her painting *Dew* was awarded second prize in Beijing fine arts competition
1984	Her picture book *Life* was awarded a bronze medal at the Sixth National Fine Arts Exhibition in Beijing
1985	Her oil painting, traditional Chinese painting, and picture book were all awarded prizes at an exhibition in Beijing celebrating the thirty-fifth anniversary of the founding of the People's Republic of China
1986	Her picture book *Five Girls and One Rope* received an award as one of the ten best picture books in the country

Selected Group Exhibitions:

1982	Exhibited at Chinese Painting Research Institute, Beijing
1983–85	"Contemporary Chinese Painting: An Exhibition from the People's Republic of China" organized by and presented at the Chinese Culture Center of San Francisco. Exhibition traveled to Asia Society Gallery, New York; Herbert F. Johnson Museum, Cornell University, Ithaca, NY; Denver Art Museum; Birmingham Museum of Art; Indianapolis Museum of Art; Nelson-Atkins Museum of Art, Kansas City; and University Art Museum, University of Minnesota, Minneapolis
1984	"Fine Arts Exhibition Celebrating the Thirty-fifth Anniversary of the Founding of the People's Republic of China," Beijing
1985	"Traditional Chinese Paintings by Fifteen Artists," National Art Gallery, Beijing. Exhibition traveled to Hong Kong and Singapore
1986	"Sixth National Fine Arts Exhibition," Beijing
	"Oriental Ink-and-Wash Exhibition," Hong Kong
1987	"Basel International Art Fair," Switzerland
	"Nine Artists Exhibition," National Art Gallery, Beijing
	"Chinese Oil Painting Exhibition," Shanghai
	"Contemporary Chinese Oil Paintings," Hefner Gallery, New York
1988	"National Exhibition of Picture Books by Ten Artists," National Art Gallery, Beijing
	"International Ink-and-Wash Paintings Exhibition," Chinese Painting Research Institute, Beijing

1988–89 "Contemporary Chinese Painting," organized by Krannert Art Museum, University of Illinois, Urbana-Champaign. Exhibition traveled to Honolulu Academy of Arts and the Elvehjem Museum, University of Wisconsin, Madison

1989 "Seventh National Art Exhibition," Beijing

"Three Women Artists: Dream of the Ancient Capitals," Plum Blossoms (Int'l) Ltd., Hong Kong

1990 "Contemporary Chinese Painting," Menam Hotel, Bangkok, Thailand

"Pintoras Contemporáneas da R. P. da China," Galeria Do Leal Senado, Macau

Selected Solo Exhibitions:

1987 "Nie Ou," Singapore

1988 "Nie Ou," Hsiung Shih Art Gallery, Taipei, Taiwan

1991 "Nie Ou: Echoes," Plum Blossoms (Int'l) Ltd., Hong Kong

Collections:

Chinese Artists' Association, Beijing
National Art Gallery, Beijing
Beijing Painting Academy
Hong Kong Museum of Art
British Museum, London
New South Wales Art Gallery, Sydney, Australia

Various private collections in Hong Kong, Taiwan, Japan, Singapore, England, Denmark, Switzerland, France, Australia, Canada, and the United States

Nancy Chu Woo

朱楚珠

1941	Born in Canton, Guangdong Province, China; moved to Hong Kong with her parents
1953–59	Took private lessons with Zhao Shaoang in Hong Kong
1963	B.F.A., Cornell University, Ithaca, NY
1964	M.A., Columbia University, New York
1964–73	Married and lived in New York; taught art occasionally
1973	Returned to Hong Kong; studied Chinese art under Yang Shanshen
1976–81	Art instructor at University of Hong Kong Extramural Department
1981–86	Art instructor at Hong Kong Arts Centre
1988	Part-time lecturer, Fine Arts Department, Chinese University of Hong Kong
1985–91	Part-time lecturer, Fine Arts Department, University of Hong Kong

Selected Group Exhibitions:

1982	"Experimental Watercolours," Hong Kong Arts Centre
1987	"Cornell Artists Show," Amerika Haus Hamburg, Cologne, Stuttgart, Munich, Frankfurt, Hanover, and Düsseldorf, West Germany
	"Far Eastern Art Annual Exhibition," Luxembourg
	"Ten Years of Hong Kong Paintings," Hong Kong Arts Centre
1988	"Asian Exhibition of Watercolours," Tokyo and Kuala Lumpur, Malaysia
	"Contemporary Chinese Paintings," East West Gallery, Chicago
	"Hong Kong Modern Art," Beijing
1989	"Art Exhibition in Commemoration of the 40th Anniversary of New Asia College, Chinese University," Hong Kong City Hall
	"Asian Exhibition of Watercolours," Bangkok, Thailand
1990	"Watercolour Works," Hong Kong Institute for the Promotion of Chinese Culture
1991	"Art Works of Hong Kong Women Artists '91," Hong Kong Institute for the Promotion of Chinese Culture
	"Art Miami '91: International Art Exposition," Miami, FL
	"Art Chicago '91: International Gallery," Chicago

Selected Solo Exhibitions:

1987 "Drawings and Paintings of the Human Figure," University of Hong Kong

1988 "Silent Poetry: Chinese Paintings," Ruschman Gallery, Indianapolis, IN

1989 "Beyond Ink and Color," Chinese Culture Institute, Boston, MA

1990 "Chromatic Visions," Plum Blossoms (Int'l) Ltd., Hong Kong

Collections:

Hong Kong Museum of Art

Various private collections in Hong Kong, England, Germany, Japan, Australia, New Zealand, Malaysia, and the United States

Yang Yanping

楊燕屏

1934	Born in Nanjing, Jiangsu Province, China
1952–58	Studied architecture at Qinghua University in Beijing and graduated in 1958; took art courses with Wu Guanzhong, Zeng Shanqing, and others as part of the curriculum; married her teacher Zeng Shanqing in 1956
1956–66	Worked at various jobs related to architecture and construction; pursued creative art work independently during free time, mostly oil painting (landscapes, figures, and portraits)
1966–76	Assigned to be art worker at the Industrial Art Design Department of the Beijing Art Agency during the Cultural Revolution and was transferred to its Oil Painting Department in 1968
1976–80	Assigned to work at the National History Museum in Beijing, responsible for duties in administration and oil painting; began to paint independently with Chinese ink-and-brush technique (*guohua*) in 1976 during free time, while continuing with oil painting
1980	Became professional artist affiliated with the Beijing Painting Academy; subsequently was elected member of the Chinese Artists' Association
1986	Came to United States as visiting artist at State University of New York at Stonybrook, where she currently resides with her artist-husband, Zeng Shanqing

Selected Group Exhibitions:

1978	"Ten-Person Exhibition," National History Museum, Beijing
1979	"Joint Exhibition of Paintings from Beijing and Tokyo," National Art Gallery, Beijing and Tokyo
1979–85	Annual national fine arts exhibitions, National Art Gallery, Beijing
1981	"Four-Person Exhibition," National Art Gallery, Beijing
1982	"Contemporary Chinese Painting Exhibition," Spring Salon, Paris
	"Painting the Chinese Dream," Smith College Museum of Art, Northampton, MA
1983–85	"Contemporary Chinese Painting: An Exhibition from the People's Republic of China," organized by and presented at the Chinese Culture Center, San Francisco. Exhibition traveled to Asia Society Gallery, New York; Herbert F. Johnson Museum, Cornell University, Ithaca, NY; Denver Art Museum; Birmingham Museum of Art; Indianapolis Museum of Art; Nelson-Atkins Museum of Art, Kansas City; University Art Museum, University of Minnesota, Minneapolis
1985	Two-person exhibition, Bawag Gallery, Vienna, Austria
1986	"Yang Yan-Ping and Zeng Shan-Qing," Heistand Gallery, Miami University, Oxford, OH
1988–89	"Contemporary Chinese Painting," organized by Krannert Art Museum, University of Illinois, Urbana-Champaign. Exhibition traveled to Honolulu Academy of Arts and the Elvehjem Museum, University of Wisconsin, Madison

Selected Solo Exhibitions:

1985 National Art Gallery, Beijing

1987 "Yang Yan-Ping," Gallery Beer-Sheba, Tokyo

 "Yang Yan-Ping," Johnson Gallery, Middlebury College, Middlebury, Vermont

 "Yang Yan-Ping," Wicks Gallery, Vienna, Austria

1988 "Yang Yan-Ping," Gallery Vindobona, Bad Kissingen, West Germany

1989 "Yang Yan-Ping," Art Gallery of Takashimaya Department Store, Tokyo

 "Yang Yan-Ping," Hsiung Shih Art Gallery, Taipei, Taiwan

1990 "Yang Yan-Ping," World Bank Art Society, Washington, D.C.

 "Yang Yan-Ping," Hsiung Shih Art Gallery, Taipei, Taiwan

1991 "Yang Yan-Ping," Davidson Gallery, Seattle, WA

 "Poetic Imagery: New Paintings by Yang Yan-Ping," Alisan Fine Arts Ltd., Hong Kong

Collections:

National Geological Museum, Beijing
National History Museum, Beijing
Lu Shun Museum, Beijing
Chinese Artists' Association, Beijing
Bawag Foundation, Vienna, Austria
British Museum, London
Miami University, Oxford, OH
Krannert Art Museum, University of Illinois, Urbana-Champaign
Hobart and William Smith Colleges, Geneva, NY

Various private collections in France, Austria, England, Belgium, Germany, Sweden, Australia, Norway, Switzerland, Japan, Taiwan, and the United States

Zhao Xiuhuan

趙秀煥

1946	Born in Beijing
1964–66	Studied at the Central Art Academy Middle School, Beijing
1969–72	Assigned to farm in Hebei Province during the Cultural Revolution
1972	Returned to Beijing; married
1973	Became professional artist affiliated with the Beijing Painting Academy and began to pursue traditional Chinese painting (*guohua*)
1985	Elected member of the Chinese Artists' Association
1989	Came to the United States; first resided in New Mexico and now lives in California

Selected Group Exhibitions:

1979–88	Annual national fine arts exhibition," National Art Gallery, Beijing
1983–85	"Contemporary Chinese Painting: An Exhibition from the People's Republic of China," organized by and presented at the Chinese Culture Center of San Francisco. Exhibition traveled to Asia Society Gallery, New York; Herbert F. Johnson Museum, Cornell University, Ithaca, NY; Denver Art Museum; Birmingham Museum of Art; Indianapolis Museum of Art; Nelson-Atkins Museum of Art, Kansas City; and University Art Museum, University of Minnesota, Minneapolis
1983	Exhibited in Switzerland, Jordan, and Canada
1985	Exhibited in Hong Kong
1986	Exhibited in Romania and Algeria

Selected Solo Exhibitions:

1988	"Zhao Xiuhuan," Crown Art Gallery, Taipei, Taiwan
	Osaka Contemporary Art Center, Japan

Collections:

National Art Gallery, Beijing
Chinese Artists' Association, Beijing
Tianjin Museum
Shenzhen Museum

Various private collections in Japan, Taiwan, Hong Kong, and the United States

Zhou Sicong

周思聰

1939	Born in Linghexian, Hebei Province, China
1955–57	Studied at the Central Art Academy Middle School, Beijing
1958	Studied traditional Chinese painting (*guohua*) at the Central Art Academy under Li Keran, Li Kuchan, Ye Qianyu, and Liu Lingcang; took private lessons in figure painting with Jiang Zhaohe at his studio
1962	Became professional artist affiliated with the Beijing Painting Academy
1985	Elected vice-president of the Chinese Artists' Association

Awards:

1959	Vienna World Youth Festival Award, Vienna, Austria
1979	Fifth Annual National Painting Exhibition First Award, Beijing

Selected Group Exhibitions:

1982	"Zhou Sicong and Shi Hu," Hua Fang Zhai, Beijing
1985	Spring Salon, Paris
1986	"Chinese Painting Exhibition," Moscow, U.S.S.R.
	"Shenzhen Art Festival," Shenzhen, China
	"Exploring New Chinese Painting," Wuhan, Hubei Province, China
1987	"Nine Artists Exhibition," National Art Gallery, Beijing
1990	"Pintoras Contemporáneas da R. P. da China," Galeria Do Leal Senado, Macau

Selected Solo Exhibitions:

1984	Art Museum at Ueno Park, Tokyo Jinan Museum, Shandong Province, China
1985	Beijing Teachers College

Collections:

National Art Gallery, Beijing
Chinese Painting Research Institute, Beijing
Beijing Painting Academy, Beijing
Chinese Artists' Association, Beijing

Various private collections in Canada, Japan, Singapore, Sweden, Taiwan, Germany, and the United States

Selected Bibliography

Albright-Knox Art Gallery. *Robert Motherwell.* Essays by Dore Ashton and Jack D. Flam with an introduction by Robert T. Buck. Exhibition catalog. New York, 1983.

Alisan Fine Arts Limited. *Modern Chinese Paintings: A Selection from Beijing, Hangzhou and Sichuan.* Exhibition catalog. Hong Kong, 1989.

Bush, Susan. *The Chinese Literati on Painting.* Harvard Yenching Institute Studies 27. Cambridge, 1971.

Cahill, James. *C. C. Wang: Landscape Paintings.* Hong Kong, 1986.

Cahill, James, Michael Sullivan, and Lucy Lim. *Contemporary Chinese Painting: An Exhibition from the People's Republic of China.* Chinese Culture Foundation of San Francisco exhibition catalog. San Francisco, 1983.

Chadwick, Whitney. *Women, Art, and Society.* New York and London, 1990.

Chang, Arnold. *Painting in the People's Republic of China: The Politics of Style.* Boulder, 1980.

Charlotte Hortsmann, and Gerald Godfrey, Ltd. *The Language of Ink: Paintings by Wucius Wong, Liu Kuo-sung, Irene Chou.* Exhibition folio. Hong Kong, 1989.

Chou, Irene. "My Mind Is the Universe: Irene Zhou Lu-yun, A Female Painter Introduces Herself." *The World of Collectors,* no. 11 (November 1990): 64–65. Magazine published monthly in Hong Kong.

Cohen, Joan Lebold. *The New Chinese Painting: 1949–1986.* New York, 1987.

———. *Painting the Chinese Dream: Chinese Art Thirty Years After the Revolution.* Smith College Museum of Art exhibition catalog. Northampton, MA, 1982.

"Critique of the Art of Zeng Shanqing and Yang Yanping" (in Chinese). *Hsiung Shih Art Monthly* 220 (1989): 56–73. Magazine published in Taipei.
曾善慶、楊燕屏作品評介

Croizier, Ralph. *Art and Revolution in Modern China: The Lingnan (Cantonese) School of Painting, 1906–1951.* Berkeley, Los Angeles, and London, 1988.

Fu, Shen C. Y. *Challenging the Past: The Paintings of Chang Dai-chien.* Arthur M. Sackler Gallery, Smithsonian Institution exhibition catalog. Seattle and Washington, D.C., 1991.

Fung Ping Shan Museum, University of Hong Kong. *Chinese Paintings by Fang Zhao Ling.* Exhibition catalog. Hong Kong, 1988.

———. *Chinese Paintings by Irene Chou.* Exhibition catalog. Hong Kong, 1986.

Galeria Do Leal Senado. *Pintoras Contemporáneas da P. R. da China.* Exhibition catalog. Macau, 1990.

Gallery Beer-sheba. *Yang Yan-ping.* Exhibition catalog. Tokyo, 1987.

Gu Chengfeng. "An Interview with Zhou Sicong" (in Chinese). *Jiangsu huakan* 121 (January 1991): 21–22.
顧丞峯、周思聰訪談錄　江蘇畫刊

Hanart 2. *Paintings by Irene Chou.* Exhibition catalog. Hong Kong, 1989.

Hantover, Jeffrey. "The World Beyond: The Paintings of Nancy Chu Woo." *artention,* no. 15 (November–December 1990): 72–74. Magazine published bimonthly in Hong Kong.

Hefner Galleries. *Contemporary Chinese Oil Paintings from the People's Republic of China.* Exhibition catalog. Oklahoma City, 1987.

Hong Kong Institute for Promotion of Chinese Art. *Art Works of Hong Kong Women Artists '91.* Exhibition catalog. Hong Kong, 1991.

Hong Kong Land Property Company, Ltd. *Irene Chou and Hou Chi Fun: Recent Paintings.* Foreword by Nigel Cameron. Exhibition catalog. Hong Kong, 1991.

Hong Kong Museum of Art. *Contemporary Hong Kong Art Biennial Exhibition 1989.* Exhibition catalog. Hong Kong, 1989.

————. *Twentieth Century Chinese Painting.* Exhibition catalog. Hong Kong, 1984.

Hsiung Shih Gallery. *Yang Yan-Ping: Lotus, Landscape.* Exhibition catalog. Taipei, 1990.

Jilin renmin chubanshe. *Selected Works by Lu Chen and Zhou Sicong* (in Chinese). Foreword by Ye Qianyu. Jilin, 1981.
盧沉、周思聰作品選集

Kao, Mayching, ed. *Twentieth Century Chinese Painting.* Hong Kong, 1988.

Krannert Art Museum. *Contemporary Chinese Painting.* Essay by Kiyohiko Munakata. Exhibition catalog. Urbana-Champaign, IL, 1988.

Laing, Ellen J. *The Winking Owl: Art in the People's Republic of China.* Berkeley and Los Angeles, 1988.

Lang Shaojun. "On Zhou Sicong's Paintings over the Past Decade" (in Chinese). *Jiangsu huakan* 121 (January 1991): 15–20.
郎紹君、周思聰十年作品略讀　江蘇畫刊

Li, Chu-tsing. *Trends in Modern Chinese Painting.* Artibus Asiae Supplementum 36. Ascona, Switzerland, 1979.

Liaoning meishu chubanshe. *Selected Chinese Paintings by Nie Ou* (in Chinese). Folio. Liaoning, n.d.
聶鷗國畫作品選

Lim, Lucy. "Contemporary Chinese Painting from the People's Republic of China." *Art International* 27, no. 3 (August 1984): 2–16.

————. "A Hundred Flowers Blooming." *Portfolio* 2, no. 2 (April/May 1980): 74–81.

————, ed. *Wu Guanzhong, A Contemporary Chinese Artist.* Introduction by Michael Sullivan; essays by Richard Barnhart, James Cahill, and Chu-tsing Li. Chinese Culture Foundation of San Francisco exhibition catalog. San Francisco, 1989.

Lingnan Art Publishing Association. *The People's Republic of China: The Seventh Art Exhibition of Chinese Painting* (in Chinese). Exhibition catalog. Guangdong, 1989.

Link, Howard A. *The Art of Tseng Yuho.* Introductory remarks by Michael Sullivan and Mayching Kao. Honolulu Academy of Arts exhibition catalog. Honolulu, 1987.

Lo Shan Tang. *Contemporary Chinese Paintings.* London, 1988.

———. *Contemporary Chinese Paintings II: An Exploration.* London, 1989.

———. *Contemporary Chinese Paintings III: Migration.* London, 1990.

Luen Chai Curios Store. *Chinese Figure Paintings: Contemporary Visions.* Exhibition catalog. Hong Kong, 1991.

———. *Metamorphosis: Contemporary Chinese Paintings.* Exhibition catalog. Hong Kong, 1990.

Ma, Flora. "First Lady of Modern Ink." *Home Journal* (March 1990): 38–40. Magazine published monthly in Hong Kong. Article discusses Irene Chou.

Moss, Hugh. *Some Recent Developments in Twentieth Century Chinese Painting: A Personal View.* Hong Kong, 1982.

Munro, Susan. "From the Universe of the Mind." *artention,* no. 10 (January–February 1990): 37–41. Article discusses Irene Chou.

Plum Blossoms (Int'l) Ltd. *Chromatic Visions: Nancy Chu Woo.* Introduction by Mayching Kao. Exhibition catalog. Hong Kong, 1990.

———. *Echoes: Nie Ou.* Exhibition catalog. Hong Kong, 1991.

———. *Three Women Artists Dream of the Ancient Capital: Xu Lele, Qian Xiaochun, Nie Ou.* Exhibition catalog. Hong Kong, 1989.

Rongbaozhai. *A Selection of Jiang Hong Wei's Flower and Bird Paintings.* Beijing, n.d.
江宏偉花鳥畫選

Sichuan Art Publishing House and Menam Hotel Co. Ltd. *The Life and Works of Nie Ou* (in English and Chinese). Contemporary Chinese Artists Series. Chengdu and Bangkok, 1989.

Silbergeld, Jerome. *Chinese Painting Style: Media, Methods, and Principles of Form.* Seattle and London, 1982.

———. *Mind Landscapes: The Paintings of C. C. Wang.* University of Washington's Henry Art Gallery exhibition catalog. Seattle and London, 1987.

Spence, Jonathan D. *The Search for Modern China.* New York and London, 1990.

Sullivan, Michael. "The Calligraphic Works of Yang Yanping." *Apollo* 23, no. 291 (May 1986): 346–49. Magazine published in London.

———. *The Meeting of Eastern and Western Art.* Revised and expanded edition. Berkeley, Los Angeles, and London, 1989.

———. "New Directions in Chinese Art." *Art International* 25, no. 1–2 (1982): 40–58.

Taipei Fine Arts Museum. *Paintings by Liu Kuo-sung* (in English and Chinese). Essays by Chu-tsing Li and Michael Sullivan. Exhibition catalog. Taipei, 1990.

Upton, Barbara, and John Upton. *Photography.* (Adapted from the Life Library of Photography.) Boston, 1976.

Wang Fangyu. *Dancing Ink: Pictorial Calligraphy and Calligraphic Painting.* Seton Hall University exhibition catalog. Springfield, NJ, 1984.

Weidner, Marsha. *Views from Jade Terrace: Chinese Women Artists 1300–1912.* Indianapolis Museum of Art exhibition catalog. Indianapolis and New York, 1988.

Wong, Wucius, Cheung Shu-sun, Kan Tai-keung, Leung Kui-ting, eds. *Lui Shou-kwan: 1919–1975.* Hong Kong, 1979.

Xue Yongnian. "The Development of Nie Ou's Painting" (in Chinese). *Hsiung Shih Art Monthly* 214 (1988): 86–97. Magazine published in Taipei.
薛永年、聶鷗畫境的形成與發展　雄獅美術

GLOSSARY OF CHINESE CHARACTERS (PARTIAL LIST)

baimiao	白描	Shanxi	山西
bingyin	丙寅	Shenyang	瀋陽
Chan	禪	shepi chengqu	涉筆成趣
Chen Qiquan	陳其寬	Shitao	石濤
chuangzao	創造	songdao	送到
cun	皴	Songjiang Zhou Luyun zuohua zhiyin	松江周綠雲作畫之印
Datong	大同	Sun Weimin	孫爲民
gengwu	庚午	Wang Jiqian (C. C. Wang)	王己千
gongbi hua	工筆畫	wenrenhua	文人畫
guohua	國畫	Wu Changshi	吳昌碩
Hebei	河北	Wu Guanzhong	吳冠中
Hubei	湖北	Wu Zongyuan	曾幼荷
Jiang Zhaohe	蔣兆和	wuchen	戊辰
Jiangsu	江蘇	Wuhan	武漢
Jiang Hongwei	江宏偉	xiaohua kaihuai	小畫開懷
jisi	己巳	xieyi	寫意
Li Keran	李可染	xinwei	辛未
Li Kuchan	李苦禪	Xu Beihong	徐悲鴻
Liaoning	遼寧	Xu Gu	虛谷
Linghexian	寧河縣	Yangzhou	揚州
Lingnan	嶺南	Ye Qianyu	葉淺予
Liu Guosung	劉國松	yuzhou ji wuxin	宇宙即吾心
Lu Chen	盧沉	Zeng Yuhe	武宗元
Lu Shoukun	呂壽琨	Zeng Shanqing	曾善慶
Luyun xiaopin	綠島小品雲	Zhao Shaoang	趙少昂
Pan Jieci	潘潔茲	Zhang Daqian	張大千
Peng Peiquan	彭培泉	Zhao Mengchien	趙孟堅
Qinghua	清華	Zhao Wuqi	趙無極
Ren Bonian	任伯年	zuoge kuaile laoshiren	做個快樂老實人